© Eric Fischer

ABOUT THE EDITOR

Anna David, author of *Party Girl* and *Bought*, has written for the *New York Times*, the *Los Angeles Times*, *Playboy*, *Details*, and many other publications. She's a regular guest on Fox News's *Red Eye*, and has repeatedly appeared on *Today*, *Hannity*, CNN's *Showbiz Tonight*, as well as on numerous other programs on NBC, CBS, MTV, E!, and VH1. She lives in New York.

D1445433

Also by Anna David

BOUGHT

PARTY GIRL

19 Writers Come Clean About the

REALITY

itbooks

AN IMPRINT OF HARPERCOLLINS*PUBLISHERS*

Shows We Can't Stop Watching

MATTERS

Edited by **ANNA DAVID**

Foreword by **JAMES FREY**

itbooks

REALITY MATTERS. Compilation copyright © 2010 by Anna David. Foreword copyright © 2010 by James Frey. "Poverty in the Time of *The Real Housewives of New York City*" copyright © 2010 by Stacey Grenrock Woods. "Faketastic" copyright © 2010 by Melissa De La Cruz. "Billie Jeanne Is Not My Lover" copyright © 2010 by Neal Pollack. "The Cutting Crew" copyright © 2010 by Jancee Dunn. "Show Boat" copyright © 2010 by Toby Young. "The Biting Hand" copyright © 2010 by Will Leitch. "Honest, Honey, I'm Not Gay, I Just Like Watching Half-Naked Buff Guys with Full-Body Ink" copyright © 2010 by Jerry Stahl. "Becoming a Lady" copyright © 2010 by Amelie Gillette. "Shelly" copyright © 2010 by Ben Mandelker. "Joining *The Real World*" copyright © 2010 by Anna David. "Gameboy" copyright © 2010 by Austin Bunn. "The After Party" copyright © 2010 by John Albert. "I Dream of Stacy" copyright © 2010 by Helaine Olen. "Idolatry" copyright © 2010 by Richard Rushfield. "How to Survive a Bachelor Party" copyright © 2010 by Wendy Merrill. "Gym, Tan, Laundry" copyright © 2010 by Mark Lisanti. "Corrupted Reality" copyright © 2010 by Rex Sorgatz. "Dog the Bounty Hunter" copyright © 2010 by Neil Strauss. All rights reserved. Printed in the United States of America. No part of this book may be used or reproduced in any manner whatsoever without written permission except in the case of brief quotations embodied in critical articles and reviews. For information address HarperCollins Publishers, 10 East 53rd Street, New York, NY 10022.

HarperCollins books may be purchased for educational, business, or sales promotional use. For information please write: Special Markets Department, HarperCollins Publishers, 10 East 53rd Street, New York, NY 10022.

FIRST EDITION

HDTV image © Vartanov/Shutterstock

Designed by Janet M. Evans

Library of Congress Cataloging-in-Publication Data is available upon request.

ISBN 978-0-06-176664-0

10 11 12 13 14 OV/RRD 10 9 8 7 6 5 4 3 2 1

For reality show fans—and its harshest critics

CONTENTS

Contents

FOREWORD

James Frey

YOU CANNOT ESCAPE IT. You will never escape it. Try as you may, you will never get away. Hope as you might, it will never go away. It's on twenty-four hours a day, seven days a week, three hundred and sixty-five motherfucking days a year. It's drunk screaming wives flipping tables. It's brave men on creaky boats complaining about the weather and praying for fish. It's policemen making arrest after arrest after arrest after arrest. It's idiotic and banal and makes you hate yourself for watching it. Teenagers spinning out over a first kiss. Parents with too many children who hate each other. It's mindless, mind-numbing, and it kills your brain. Hipsters in their early twenties pretending to live normal lives, men auditioning wives whom they will never marry. It's a complete, utter, and absolute waste of time. Contestants on an island, in the jungle, in the wilds of China, in the depths of Africa, whoever wins gets a million dollars! It makes you feel like a fool. Cougars, MILFs, wife swapping, speed dating!!! It's on from dawn to dusk, and into the depths of the night. You can't get enough of it, and you can't live without it. It's reality television. You will never fucking escape it.

I love reality television. I watch some form of it almost every day. Today, this minute, as this file sits open before me, my

computer on my lap, my feet up on a table, my ass on a couch (where it often is and feels very comfortable), a remote next to me, there are, according to the digital channel guide provided by my digital cable provider (Time Warner Cable of New York City), eighty-eight reality shows available to me. I define a reality show as something constructed to resemble reality, where a camera crew follows people around while they do something. That something can be, and at this point has been just about anything, though the producers (move the fuck over, Einstein) keep coming up with new things (*Board Breaker*—about a Norwegian kung fu master, also a widower and a single father to two adorable blond girls, who has devoted his life to breaking boards with his hands, feet, head, and every other part of his body and is trying to set a board breaking world record). The best of the shows are entertaining, informative, moving, and heartbreaking, and inspire us to become better people (*The Biggest Loser*). The worst of them, which are often the most fun to watch, are evil, cynical, nasty, mean, and ugly, and inspire long, hard laughter (*The Biggest Loser Reunion: One Year Later*). The shows, more of which appear on my digital channel guide every day, have all but taken over television. They're cheap to make (all you need is a crew, the subjects, and a team of editors to manipulate the footage), and there is an endless supply of people willing to be in them. They can be targeted to highly specific demographics (single female seniors living in rest homes in the Midwest) so that highly specific products can be placed in them or advertised on them while they're broadcast (adult diapers and romance novels). They cross cultures, cross racial and ethnic lines,

cross religious barriers. They appeal to members of every socioeconomic class and social strata. They are watched by viewers of every age and every generation. And they're a dream for network programmers. They eat up hours, attract viewers and advertisers, and there's little at stake if one of them fails. For someone like me, we are living in a golden age.

My first memories of watching a reality show are the hours I spent with *The Real World: New York*. First broadcast on MTV, in 1992, it was, at the time, a revolutionary idea: stick some people in their early twenties in a big place to live and follow them around while they go about their lives. It was also a re-markably simple idea, the kind of idea that made you angry that you didn't think of it yourself. Initially, when I first saw the ads and promos for it, I wondered why I would want to watch it. I had enough bullshit in my life—girl problems, too many drugs and too much drinking, no job and no desire to have a job. Why would I care about someone else's? Once it started, though, people began talking about it—about the drama of it, about their favorite cast members, about what they thought would happen next. It sounded remarkably like a normal TV show, except that the people were real, and lived in the real world. I got high one afternoon and tuned in. I don't remember where in the season they were, or what happened on the episode, and it doesn't matter. I saw people doing shit that I could identify with, except that it seemed cooler, more exciting, more dramatic, more difficult, more rewarding, more perilous, more of everything, and, most important, more real. I was fucking hooked.

I watched that season, and the next, in Los Angeles, and the next, in San Francisco, and I've watched every season since.

For a long time I didn't know why I liked it or what made it more real to me or why I continued watching, along with millions of other people. And then the real world descended on me—the real real world—and I had to make money and support myself and figure out what the fuck I was going to do, and I started writing. At first I wrote bullshit in journals about my daily comings and goings, then I wrote films, then I started writing books, or trying to write books, based on my own life. As it did on *The Real World*, and on every other reality show, shit happened, some of it good and some it bad, some of it exciting and some of it boring. I had highs and lows; I had heartbreaks and triumphs; I loved and I lost. When I started writing about it, I realized it wasn't enough to just document it or to portray it in some objective way; it needed to be manipulated, altered, heightened and diminished, it needed to be edited for effect, and for pace, and for structure. That to tell a story, and tell it well, one needed a beginning, a middle, and an end. That to tell to a story, and tell it well, life, reality, day-to-day events, could be a *basis*, but that additions would need to be made to make the story live and breathe and function, to make it seem like life, to make it seem real. I learned the great secret of reality television, and of writing, and of every other form of narrative self-documentation and narrative storytelling: that it's all fake, every second of it, every minute of it, every page of it, every episode of it. It's all fucking fake. Manipulated and embellished and edited. Fake so that it can be real. Structured and polished. Fake so that we can consume it and connect to it and identify with it and enjoy it. Made to entertain. We call it the real world, but it's not. It's all fucking fake.

And to me, at least, it doesn't matter. I don't care. Actually quite the opposite. I revel in reality's fakeness. I celebrate it. Support it. Preach its gospel. I drink it, eat it, let it flow through me. I let it move me and make me laugh. I let it piss me off and make me sad. I let it take me to places I would never go or see or know anything about. I let it entertain me, and educate me, and sometimes—and this is always sort of shocking and sort of lovely and wonderful—it enlightens me. I let it occupy hours and days and weeks of my life. Fake reality. The unreal real world. Some reasonable semblance of the world reengineered to be more reasonable. Abnormal normalcy. It's the future, this state, this dimension, this way of disseminating. It's where our world, with virtual reality, with twenty-four news stations broadcasting different versions of the same events depending on their political philosophy, with memoirs full of truth but lacking fact, with newspapers more fictional than novels, with movies based on Hollywood's version of real life, with presidents and leaders of nations, both past and present, making shit up so they can go to war and pass laws and shape the world to their own vision, it's where our world is going, or has already gone, or is right now. And I love it. Fucking revel in it. Celebrate it. It allows me, or you, or anyone else on this planet, to believe what we want to believe. To find what speaks to us. To create our own reality. To live in that reality. To be entertained in that reality. And to make that reality real. As real as anything else, and as true as anything else, and as valid as anything else. You cannot escape it. I said it before and I will say it again: You cannot fucking escape it. So sit back and make yourself comfortable and have a sip from a nice cold beverage

and maybe a snack or two. It's your choice. It's your life. It's your reality. It's your story to tell or watch or read or write, to love or hate, to manipulate, embellish, edit or structure in any way you want. It's your show and your channel. It's on twenty-four hours a day, seven days a week, three hundred and sixty-five motherfucking days a year. You cannot escape it.

INTRODUCTION

Anna David

I'VE ALWAYS BEEN SOMEWHAT ASHAMED of my lowbrow sensi-
bilities. I was raised in a house where the multiple bookshelves
were stacked with everything from Austen to Zola and Beethoven
blasted from the speakers. Of the four of us—me, brother, Mom,
Dad—two have PhDs and two went to Harvard and I'm in nei-
ther group. Growing up, the way I dealt with the inferiority
complex all this brought on was to simply to snap off the stereo
that was always blasting classical music whenever I passed it
and stubbornly tune in to *Three's Company* in one room while
everyone else reveled in *Masterpiece Theatre* in the other.

And now? Well, I know I should be reading Dostoyevsky,
watching *Brideshead Revisited,* seeing *Hamlet* at the Metro-
politan Opera, and listening to Symphony No. 9, but instead
I'm scanning Gawker, declaring Nelly one of my favorite musi-
cians without a hint of irony, and lamenting the fact that I
didn't manage to see *9 to 5* before it left Broadway. And even
though books are, bar none, my favorite form of entertainment,
I'm woefully illiterate in many ways. The truth is, I can barely
even pronounce Dostoyevsky.

I'm also obsessed with fake reality. I've published two
novels, and the undercurrent of both is, essentially, that what
we project is far different from who we really are. And yet, per-

haps ironically, I have a nasty habit of comparing how I feel with how other people look, usually selecting the most successful or joyful-seeming individuals I can find and invariably concluding that my life is terrible because I don't have their 2.5 children, house, or bestselling book. Reality TV, with its seemingly endless supply of horrible people to feel better than, offers a glorious antidote to this.

The truth is, I didn't stand a chance against reality television. If I'd worked hard to avoid it—the way I've staunchly avoided, say, learning about opera—I think it would have sucked me in anyway.

Despite an infatuation I'd long had with one reality show (see page 91), I didn't become tethered to my television during the onslaught of reality TV in the 2000s, when *Survivor*, *Who Wants to Marry a Multi-Millionaire*, and *Trading Spaces*, among others, all kicked off. At that point I was truly susceptible to only a certain flavor of reality—specifically the kind that focused on attractive, thin, wealthy people who seemed to have something I wanted (in some cases, merely the temporary house they were in) but who nonetheless managed to seem more screwed-up than me. Or just thin, pretty people competing with one another and thus displaying whatever viciousness or charm would carry them to victory.

Somehow, it was a quick descent from interest to obsession. By the time I was semi-hysterically texting friends when I saw Santino from *Project Runway* at a party, I'd swallowed the Kool-Aid, powder and all.

And then, rather suddenly, I found myself making money as an "expert" on reality television. When I wasn't writing a reality TV column for the Fox News Web site, I was chatting about

who had betrayed whom and with who for a show called *Reality Remix* on Fox's Reality Network. And I learned, through repeated exposure to everything from *The Apprentice* to E!'s *Filthy Rich: Cattle Drive* (an underappreciated ode to spoiled Hollywood kids that featured a pre–*Keeping Up with the Kardashians* Kourtney) that I was fully capable of getting excited about *any* reality program. The same elements of the pretty people shows that hooked me—the overdramatization, the delusional behavior—were in play on every episode of every show. Greedy, inspiring, stupid, scheming, hilarious, self-aggrandizing—whatever the situation called for, each participant, thanks to some slick editing, filled out his or her stereotype perfectly.

Through some extremely unscientific research, I determined that other writers were equally obsessed with this form of entertainment. Most of us are home all day, aching from within the depths of our souls for new forms of procrastination. We're observers of life and usually focused on creating interesting characters or filling our scenes with dramatic tension—both essentials for gripping reality TV. We also probably have some narcissism running through us (as Tennesee Williams once said, egomania is almost the precondition of all creative work). And many of us fight to become a part of the cultural conversation in a way that your average *Rock of Love* seems easily able to, so there's always the possibility that our interest is laced with a dash of masochistic envy.

Turns out, I was right—about the passion for the topic, if not about the reasons behind it. Of the initial list of writers I contacted, only one said he didn't like reality TV; in the next sentence, he confessed that he didn't actually *own* a television. Instead of worrying about making sure that every single

genre or channel was represented, I asked each writer to pick the show they were most obsessed with. And the results were even more revelatory than I'd imagined: from Jerry Stahl speculating that the prisoners on *Lockup* had actually made it—after all, they were being televised—to Jancee Dunn envying the designers on *Project Runway* for the fact that they could be creative in groups while writers have to work alone (or in the company of cats), to Toby Young giving a hilarious play-by-play account of appearing on a BBC show, to Rex Sorgatz analyzing how much reality television is merely reflective of the falseness that makes up everyday life, to John Albert confronting the "villain" of *Sober House*, to Stacey Grenrock Woods examining what it's like to live in semi-poverty in the wake of *The Real Housewives*, to Neal Pollack tracing his own former fascination with unstable women through the prism of the wayward lass on *Married by America*, to Richard Rushfield coming clean about how covering *American Idol* for the *Los Angeles Times* turned him into a fanatic with the tattoo to prove it, each essay reveals as much about the writer as the show—and about why the form of television everyone's always predicting will go away shows no sign of diminishing anytime soon.

With this book, I wasn't terribly interested in trying to figure out just how *real* reality television is. I don't actually care whether scenarios are scripted, if cast members are manipulated into behaving certain ways, or what shooting is like. I definitely don't want to hear anymore from the reality show participants than I already have.

Instead, I wondered what we, as a culture, are getting from this form of entertainment. Why, in short, do we want to watch

people we don't know sing, sew dresses, eat maggots, lose weight, have sex, kick drugs, sob hysterically, or display their abs? What does this say about us—and the social, political, sexual, and psychological climate of the time we're living in? While it would be impossible to come up with one definitive answer to these questions, I'm proud to say that the writers featured in this collection provide the most compelling theories and ideas on the matter I've ever seen while in the process addressing love, honesty, identity, denial, vanity, fame, and a great many other culturally relevant issues in unique and often quite hysterical ways.

Reality show aspirants—from the Balloon Boy's parents to everyone's favorite White House party crashers—have gotten a bad reputation as of late and have truly come to represent the nadir of our world today. But do we blame the form of entertainment that supposedly motivates them to pull their stunts or the public who can't get enough information about them? Or do we just own up to the fact that many of us enjoy a glimpse into unreal reality? I say there's nothing shameful about feeling genuinely disturbed by Adam Lambert's *Idol* loss or gleeful over Kelly Bensimon's numerous post-*Housewives* scandals. And just because our TiVos deliver us regular doses of *What Not to Wear*, *Big Brother*, or *The Bachelor*, that doesn't mean we can't listen to Beethoven or read Dostoyevsky.

It doesn't mean we have to, either.

REALITY
MATTERS

1

POVERTY IN THE TIME OF
THE REAL HOUSEWIVES
OF NEW YORK CITY

Stacey Grenrock Woods

"IF JILL CAN DROP sixteen thousand dollars on a bag," beamed Kelly Bensimon, the newest housewife on Bravo's *The Real Housewives of New York City*, "then I say, go for it!"

"Go for it" is excellent advice, especially from someone who designs owl jewelry and jogs in traffic. Bensimon was referring to her fellow housewife Jill Zarin's televised purchase of a garish green handbag. It really was, as the price tag showed, sixteen thousand dollars. Most people, even the obscenely rich, wouldn't go for such a thing so publicly in late 2008, when season two of the series was shot. But the Real Housewives will go for anything—parties, purchases, press lines, each other's jugular veins—as long as it means more of that precious commodity: attention.

In late 2008, I was going for things too: enough change for a meal at McDonald's, a lot of walks (my oxidized green 1991 Saab had long stopped going for it), and down to the mailbox, hoping vainly for a check. Work had been scarce for some time. I'm a writer and my husband, Kenny, owns a recording studio, so of course we are insurance-free. Unable to afford our antidepressants, we went off them, and our bodies seemed to turn wholly edematous within hours. Our new Top Ramen and Quarter Pounder diet was counterproductive to our health goals. Also, his teeth were steadily rotting. Each newly sprouted abscess thwarted our few remaining dreams. We couldn't afford to take drugs, and even the plants curled up and died. Jill Zarin's throwaway sixteen thousand would have made all the difference in the world to us, so it's tempting, and it would be great fun, to rip the Real Housewives for having so much when so many have so little, but we all know things don't work that way. Besides, I'd rather rip them for being stupid and awful. I feel it's more appropriate.

The housewives brought this on themselves. Not content to be privately rich and terrible, they belong to that rare and now overrepresented class of people who have always thought, "You know what? *I* should have a TV show. They should make a TV show about *me*." Fans of the series could easily imagine Jill Zarin saying something like this in her Long Island brogue. I like to daydream about how each cast member made the decision to audition for a reality show; how they all thought it over and decided, "Yes, the best thing for me and my loved ones is to have our lives derided by as many people and through as much media as the current technology will allow." It will be, they surely told themselves, good *exposure*. I want to be on televi-

sion, they surely said. I'll come off well. Besides, it's all in good fun.

No it isn't.

For several years I was a correspondent on *The Daily Show*, both with and without Jon Stewart. I reported on ridiculous people doing moronic things (or was it moronic people doing ridiculous things?) for exposure all over America. I loved this job because I got to be on television, and because I got to make stupid people look stupid on television. Of course, no one producing entertainment of this kind would ever admit to mocking anyone. "Celebrating" is the euphemism of choice. I can't tell you how many times I sat in meetings and listened to development executives beam about their new projects: "We're not mocking these people," they'd say, "it's not mean-spirited at all." (It's at this point that another executive or two would echo the sentiment with an "Oh, no!") "That's not what we're *about*," they'd insist. "We want to *celebrate* these people!" I'll bet people at Bravo say this sort of thing an awful lot. I imagine that Bravo executives celebrate the fuck out of "these people." I'll bet they're "all about" it. But these people shouldn't be celebrated. They should be mocked—roundly mocked—with the meanest spirits we can muster—because capital "r" Reality is getting far too close to real reality for my comfort.

Of course the Real Housewives aren't really housewives. (Students of Reality should by now have a natural suspicion of any show with the word "real" in the title.) At the time of this writing, only three of the six are technically wives, but like nuns who have taken a vow to God, the Real Housewives are wedded to the media, forsaking all others. Season two (one of the rare superior sequels in art) saw our girls feathering not

their nests, but their brands. And by their brands we shall know them:

There is a countess on the show. It's okay if you forget—the countess will consistently remind you by dropping hints like "I'm a countess" and by referring to herself as "the countess." Those interested in how former "catalog model" LuAnn de Lesseps became a countess can read the whole fairy tale in her gracefully ghostwritten etiquette guide/memoir. (Or I can save you the trouble: she married some count. He was rarely seen on the show because, as it turned out, his Ethiopian mistress demanded much of his time. Fortunately, the countess will retain her title after the divorce.)

Natural foods chef Bethenny Frankel (two *n*'s, two *e*'s) has spent season two promoting her Skinnygirl (one word) brand: Skinnygirl cocktail mixes, Skinnygirl wheat-, egg-, and dairy-free baked goods, and a peppily ghostwritten book about how you can be a Skinnygirl yourself. Skinnygirl, Skinnygirl, Skinnygirl. Let's all say it! Although formerly branded the show's underdog (because she was, until recently, unmarried, goofy, brash, doesn't like to be touched, and has a bite radius of such might and scope that it could come only from a lifetime of grinding through even the stealthiest of nightguards), Bethenny Frankel seems to be reaping the most rewards from her decision to go for a reality show, her second. She is certainly faring better than she did on *The Apprentice: Martha Stewart*. We're all very proud of our Bethenny. All of us, that is, but Kelly Bensimon.

Kelly Bensimon, former model, current horsewoman, is the newest housewife. Tan and torrential, she has no time for anyone she doesn't consider "amazing" (she means "famous").

Her remoteness and unrepentant snobbery keep her at odds with Bethenny and have managed to offend even the countess. A woman of many whims and at least as much alimony, Kelly is a tremendous figure on the Manhattan/Hamptons/Owl Jewelry scene. And she works, too: she goes to parties and "writes for articles." I'm not sure what that means, but in any case, Kelly is fiercely protective of the Bensimon brand.

Simon van Kempen and Alex McCord have always reminded me of the Veneerings, Charles Dickens's nouveau riche climbers whose furniture "smelt a little too much of the workshop and was a trifle sticky." Their one-night stand born of an Internet chat room has blossomed into a beautiful life in Brooklyn with their two small but vigorous boys, Johan and Francois, who impress everyone with their command of Latin and their genius for running around at parties, screaming and stabbing things with steak knives. The show takes every opportunity to insinuate that Simon, often called the seventh housewife, is gay. I don't think he's gay. Nor do I think he's straight. I think he's just Australian, and a con man. The van Kempens don't fool me. Simon has implied on camera that he owns the Manhattan hotel he only manages, and everything about them tells of colossal debt and vague horseshit. When their sons are old enough to comprehend their parents' publicity, I'm confident the boys will, as they say, "go Menendez." Naturally, the van Kempens are writing a parenting memoir. (No word yet on who's ghost-writing.)

Ramona Singer is the one with the "crazy eyes." Her husband, Mario, sells religious jewelry, and must sell an awful lot of it from the looks of their Hamptons house. Despite her protests otherwise, Ramona doesn't do anything, leaving her plenty

of time to offend people at parties. "You're, like, blind, right?" she asked New York Governor David Paterson, who is blind. She went on to tell him that she's, like, blind, too, without her contacts. Convinced of her irrepressible youthfulness, Ramona is "developing" a line of anti-aging skin care products that she hopes to sell one day on QVC. She also has a line of jeweled T's—but these days who doesn't?

Which brings us to Jill Zarin, the Fabric Queen. Jill, in the space of one episode, bought that $16,000 bag, turned down her husband's gift of a new Mercedes because it lacked a specific dashboard dock for her iPhone, and spoke at length about the size of her diamonds. But it's all right, because Jill does charity work—or, I should say, helps organize some charity fund-raisers. (Choosing a tapenade and deciding where the Zarin Fabrics logo will appear on the invitation *is* work, after all.) On one episode, Jill spoke to the BBC about the world economic crisis. "Economic crisis" would have waved the red flag of mockery right in the face of most people, but not Jill Zarin, who is ravenous for publicity. When asked if she thought it fair to have so much when people in Africa, for example, are starving, Jill said that life isn't fair—but, funnily enough, she had just raised money for a school in Africa. She even cited the "teach them to fish" idiom so popular with the very rich. To her credit, she was able to repeat the phrase correctly, unlike the time she spoke of "kicking a gift horse in the mouth."

With so many vivacious personalities competing for screen time, it's no wonder our housewives occasionally step on one another's toes. What usually happens is something like this: Bethenny Frankel is chosen to be on the cover of *Social Life* magazine (the only magazine I've heard of where the stylist

picks the cover story). Immediately upon hearing the exciting news, the countess asks if the magazine will be doing any retouching. Bethenny is understandably hurt, and asks the countess to lunch to discuss the hurting. When pressed, the countess explains that her comment was not evidence of jealousy, but merely her protective model's instinct kicking in. Furthermore, the countess can't understand why Bethenny is being so "attackive" toward her. Later on, Bethenny goes on the attackive herself by calling into question the countess's authorial credentials (which is a ludicrous notion to anyone who's ever seen the countess hashing it out with her ghostwriter!). To soothe her image, the countess, in a black dress and a pair of knee-high suede boots, takes a town car to the Madison Square Boys & Girls Club to inspire a group of underprivileged, underfunded, underloved, and misunderstood black girls. After a proper introduction, she begins her talk with "My husband's family—get this, 'cause it's fun—built the Suez Canal." After what surely felt like hours, the countess asks the girls what they want to be when they grow up. One girl says she wants to be a model. On top of being underprivileged, underfunded, underloved, and misunderstood, I'm sorry to say this girl looked to be grossly overfed (although, judging by the quality of food most easily afforded by the poor in America, she could have just been bloated like I was).

"Stand up," ordered the countess. "How old are you?"

"Ten."

"Oh," said the countess, "you have plenty of time to grow." The girl stood very still. "You have a beautiful *face*," said the countess, before taking a sip of the bijou coffee drink she had brought along. The girl remained heartbreakingly still. We all did.

"And you know what?" No, Countess. What?

"Losing weight is *easy*!"

There it was and there it stays, on national television, for all to see, rerun after blessed rerun.

"I think they got a kick out of seeing me in my high heels on the basketball court," the countess later said. "And they really appreciated me taking time out of my day."

It occurs to me now that I haven't mentioned, for all those who want to buy it, the name of the countess's book. It's called *Class with the Countess* and comes to us courtesy of Gotham Books. (Thank you, Gotham Books.)

Another major attackive that runs through most of season two started at the meeting for an arthritis charity fund-raiser that Jill Zarin was helping organize. Well, really it started long before that. It really started each time Bethenny was, she felt, systematically ignored by the towering Bensimon at various stops along the Manhattan party circuit. The countess asked Kelly to come along to meet the other housewives and get involved with the Creaky Joints event. She showed up classically late and was introduced to the group, which included Jill's teenage daughter, Allyson.

"Cute!" said Kelly Bensimon, upon hearing that Allyson is herself afflicted with arthritis. The other women seemed a little taken aback, but proceeded with business. They were told that, as honorary co-chairs, each woman's name would appear on the invitation. At this, Kelly perked up. (You'll recall that Kelly is very protective of the Bensimon brand.) She flat-out refused to have her name associated with the charity. Kelly Bensimon, according to Kelly Bensimon, doesn't lend her name to just anything. Why? Well, for one thing, she's super-busy.

"Like, I have, literally, fifteen more minutes," she told them, "and then I gotta go." That's how busy she is. Everyone there looked rightfully wounded, and Bethenny made a light crack about Kelly thinking herself Madonna. I felt the remark was justified; I think we all did. Kelly, for unknowable reasons, took issue with the comparison.

That is what prompted the legendary "I'm up here, you're down here" exchange, during which Kelly used hand gestures to demonstrate how much higher she is than Bethenny on the social ladder. It happened at a cocktail date called by Kelly to discuss the hurting—a cocktail date to which Kelly was half an hour late.

Throughout the season, numerous attackives are flung about: Jill calls Simon a drunk in the press, Ramona calls the count "old," and everyone calls Simon gay. Eventually, Kelly, who we indeed see lending her name to just about anything throughout the season, recants and helps out with the Creaky Joints auction, and despite a gigantic screaming match over what Jill felt was an abundance of Bethenny's Skinnygirl signage, the climactic event goes well and Ramona offers everyone "kudooz." The van Kempens, with the help of the show's sponsor, General Electric, redo their apartment, and there is also a tennis side plot, manufactured and uncompelling, between Jill and Mario, but I don't care about any of that. I care about the real stuff: "the weight," "I'm up here," "retouching," "Madonna," "drunk," "gay."

Here in the spring of 2009, work has begun to trickle down our way. We can currently afford weekly groceries, and our bodies, finally free of pharmaceutical impediments, have regained their rightful sizes. Stunningly, one of the plants has

even come back to life. We live for Tuesday nights and always say the same thing after *The Real Housewives* is over: "I wish this show were ten hours long."

What troubles me, though, is as much as they are mocked, the housewives are also being celebrated. Quick visits to the Bravo message boards during the second season revealed an outpouring of ungrammatical love and support, even for the ones I consider the vilest. It's working: they are crossing over. As the self-appointed gatekeeper of truth, I plead with anyone who's still reading *to not let it happen*. Do not feel for them, do not buy their muffins or their skin cream, do not buy their books (publishers, I'm talking to you). Don't let "these people" use their freak-fame to step over to legitimacy. Legitimacy belongs to us: the real, the poor, and the decent. We must come together, finally, and laugh at the laughable, the terrible. Yes, *at* them, not *with* them, *at* them, *at* them, *at* them, *at* them! And although Bethenny Frankel's book is at number twenty-three on Amazon and mine is, when I last checked, substantially higher, I have a little attackive of my own: Reality Star. No one's getting across.

2

FAKETASTIC

Melissa de la Cruz

MTV'S *THE HILLS* GETS A LOT OF GRIEF for its relationship to reality. Mainly that it has none. The situations are scripted! The drama is forced! What *Teen Vogue* intern also graces its cover? *C'mon!* That's not reality, that's . . . orchestrated! Manipulated! Fake! Fake! Fake! And yet, for all the rotten tomatoes hurled at it, the documented lives of young women in Los Angeles is one of the highest-rated shows on the network and has made tabloid sensations out of its stars.

So what's going on here? I, for one, am addicted to *The Hills*. I love the fairy-tale-in-LA premise, with its shiny Range Rovers and club openings in place of carriages and royal balls—and the toothsome and uncomplicated prettiness of its former main attraction. Lauren Conrad is the epitome of eye candy. I could watch Lauren watch paint dry (with that glazed-eye look of

concern she has when listening to someone else talk). She has a fresh-faced California beauty that recalls a young Alicia Silverstone: that hair! (so thick, so blonde, so glossy!), those teeth! (so white! so blinding!), all wrapped up in a friendly, accessible package.

She's the benevolent princess we all knew in high school: rich, pretty, and *so nice*. You know, the girl even the nerds worshipped because she would let them do her math homework. We like Lauren. We root for Lauren. And yet—we also kind of hate her, the way we hate anyone who seems perfect and perfectly smug. Lauren isn't quite smug, but she is self-serving, and showed her true colors in the love triangle that capitulated *The Hills* from tame *Melrose Place* reality copycat into riveting must-see TV (at least for those of us who like our entertainment sprinkled with a thrilling dash of high school pettiness). I am speaking, of course, about her reaction to the creation of Speidi.

From the beginning, Heidi Montag, the ditzy blonde working her way up as a club promoter, was the perfect foil to Lauren's rosy-cheeked golden-girl ideal. Unlike Lauren, Heidi was more of a hard-luck case—the Lea Thompson in *Some Kind of Wonderful* role, if you will. The sort of pretty girl from the sticks running with the Beverly Hills chicks. Heidi is from Crested Butte, Colorado. Her parents are divorced. With a big nose and flat chest, she wasn't as attractive as Lauren, but like most of us, she passed for cute because she *tried*. (When Heidi had a nose job and her boobs pumped in the second season, I didn't blame her—at least until she bacame the poster child for plastic surgery addiction.)

Heidi and Lauren were *besties,* and it was easy to under-

stand why they liked each other. Lauren because Heidi would never be a true rival for the crown, and Heidi because Lauren was the It Girl, and those of us who strive to be It like to be as close to It as possible so that we may benefit from its reflected glory. Lauren needed an entourage to promote her queen-bee status and Heidi was comfortable being second banana. Heidi was fun and also fun to watch: a lot less guarded about her image than Lauren, Heidi would complain about her five-hour work week and roll her eyes at co-workers.

Much like most women who remain glued to *The Hills,* at certain points in my life, I've *been* both Lauren and Heidi (but more often played the "Heidi" to a friend's "Lauren"). The Lauren-Heidi dynamic is really an ode to the high-school friendship: a black-and-white way of looking at the world. One is rich. The other is not. One is pretty. The other is not quite. One is popular. The other would like to be. My own "Heidi" phase occurred when I was a financial aid student at Columbia. Sure, there were many other nice, earnest, hardworking kids to hang out with. But I wanted to have fun—to go to nightclubs and cool parties, to do the stuff that comes naturally to kids with resources. The typical student scraping by on a work-study program didn't know how much a table at Au Bar cost, let alone where it was, and I wanted to.

There was no middle class at my college. You were either a trust-fund kid or a scholarship student. I'm not from Crested Butte, Colorado. But I might as well have been. My parents were rich once, when we lived in Manila, but who cares? They weren't rich when I went to college, and by that time, the memory of our chauffeur-driven lifestyle had faded with the reality of our humble circumstances: running the employee

cafeterias at several Sears stores. (To this day, the thought of Sears sends a shudder down my spine.)

My Laurens were rich-girl Natashas as described by Tolstoy: Girls who had everything and were made even more attractive by the abundance of charm and luck in their oh-so-privileged lives. My first Lauren was my roommate: a sloe-eyed bohemian who slept on Laura Ashley sheets and left her Swiss gold necklaces in the sink. I still remember how fluffy her Ralph Lauren towels were.

Caitlyn had an irresistible confidence. Although she is nothing—at all—like Lauren (she's a classic NPR canvas bag girl and would die before driving a Mercedes), she did have Lauren's ability to command a room. Because—well, simply because she was Caitlyn. Several different boys were in love with her every week. They would troop into our room, looking for her, leaving behind little books of poetry or other tokens of their devotion. I'd never seen it before, but it's true: there are the pursued and the pursuers, and some girls are lucky enough to fall in the former category.

This is a tangent, but bear with me: The whole poor-little-rich-kid story we're spoon-fed in mass media simply doesn't ring true to me. Sure, *some* rich people are awful and neglect their kids, but from what I've seen, mostly the opposite is true. The rich parents I've known have been devoted, engaged, active, and interested in their kids' lives. They keep a stable family unit. And this is what I mean by these girls being Natashas—they were rich in every sense of the word: rich in material things and in the things that really matter. Caitlyn's family was close-knit and glamorous. Her parents had been married for forty years. Her sisters worked for magazines or educational think

tanks. They were connected to a vibrant network of insiders. Caitlyn never once had to use the college employment office. Upon graduation, she got a job at *Vogue* through her sister's friend. Lauren's parents don't seem to be too far from Caitlyn's. The Conrads are still married. And they helped her expand her business empire and brand: the fashion line, the YA books.

But back to Lauren and Heidi, the duo joined-at-the-shopping-bag—until, that is, Heidi fell for Spencer Pratt. (This is one of the reasons that *The Hills* is so great: you can't make up a name like that! It's Dickensian in its awesomeness.) Spencer, with his whiny bratty voice and gelled hair, totally lives up to his name. Like Heidi, he's not gorgeous but passes for attractive by being skinny and tanned. And he hates Lauren since only a fake can call out another fake.

Because Lauren is a big fake, as it turns out. She's not quite the perfect girl she seems to be and, in fact, pulls the most common and manipulative female friend move of all time by telling Heidi whom she can and can't date. If you are a woman who's ever had a close female friend, you know what I'm talking about. Maybe, like me, you've had a Lauren in your life who wraps her jealousy and insecurity in a blanket of false concern about *your* well-being. She's doing it only because she cares about you! He's going to hurt you. He'll cheat on you, he'll leave you, you're better off without him!

Lauren had ammo: Spencer flirted with *Playboy* models. He asked their friend Audrina out. He had all the makings of a total cad. One look at him in his pastel polos and blingy Rolex revealed as much.

For her part, Heidi heard her friend out with a look of immense patience on her face. Watching the show, I applauded

her for not slapping Lauren upside the head and leaving right then. Because instead of just telling Heidi she couldn't date Spencer, Lauren put *their entire friendship on the line*. She gave Heidi an ultimatum: him or me. Which is just. I mean. No. No. No. No!

There's a certain camaraderie to being single women together, and Lauren showed just how ugly that relationship can turn when its balance is threatened by a man. Female friendship is intimate and close. When you're together, a girlfriend is both wingwoman and partner in crime—a sister, a rival, a confidante, and the one you can count on to share popcorn with at the opening of the new *Batman* movie on Friday night. But when one of you becomes attached, the Wonder Twin powers collapse. Suddenly someone is the third wheel. Maybe Lauren never saw herself in that position and was appalled by it. Her rotating sea of boyfriends come and go, and yet Heidi and Spencer have been together for many seasons now, weathering a succession of fake engagements (and an actual marriage).

Funnily enough, the main Lauren in my life was a gay man. And he proved to be more like Lauren than Caitlyn ever was. Morgan was British, with a sardonic wit and designer wardrobe. He had lived in Paris and spoke fluent French. Like Lauren, he had honey-blond hair and was always tan. And, also like Lauren, he dumped me when I started dating someone.

It was that simple: he just stopped talking to me after I'd been with Mike, the man I ended up marrying, for three months. Like Lauren, he was insecure, jealous, and threatened. And the minute he dumped me, I knew he had never really been my friend.

If Lauren really cared for Heidi, she would be there to pick up the pieces if it does ever end with Spencer. But to dump a friend just because you don't like her boy? That's seriously lame. And we all know what's behind it: selfishness. Except for Lauren, it seems. And we forgave Lauren this flaw (the princess is human, after all!) but also enjoyed the thorn-in-her-side spectacle that Spencer and Heidi became. When rumors of a Lauren Conrad sex tape surfaced (initiated and circulated by Heidi and Spencer, according to Lauren), our golden girl started to look more like the golden goose.

My favorite part of the ultimatum episode was when Heidi had to choose. And here's where MTV's cheesetastic editing made for great television. We see Heidi waiting in a darkened lobby. A fabulous, shiny, and very expensive car pulled up to the driveway, Spencer grinning at the wheel. Heidi walked up to the car wearing a tight dress and high heels, her hair long and loose—that windswept salon look. A small smile played on her lips.

Spencer said, "Hey, beautiful."

And she got in the car.

She chose the guy over her frenemy.

And who could blame her?

There's not one girl among us who doesn't think a guy who says "Hey, beautiful" to his girl can be *all bad*. Spencer, you had me at "Hey, beautiful."

I've dated a decent number of dudes in my life, and the only boy who ever called me beautiful is the one I married. I still remember how it happened, too. Mike was a grad student and lived uptown, while I had an apartment in the Village. He would come down to see me and then take the red line back up

to Columbia in the wee hours of the morning. One night, early in our courtship, I told him he should just stay. And he did, because "How can you say no to a beautiful girl?" I mean. Can you even? I think we'd been dating for only two weeks by then but it was at that moment that I knew he was "the one." (When our daughter was born, Mike took her into his arms and said, "Hi, beautiful." I told you: a keeper.)

Whatever happens between Lauren and Heidi (for now, they've made their peace: they're not going to be friends but they will be friendly), I'll always have a soft spot for *The Hills*. The show is artifice inspired and cut like a music video; the dialogue is awkward and stilted, as only real conversations are (no one is really as witty as Chuck and Blair on *Gossip Girl*); but somewhere, just ever so slightly below its glossy surface, is a real portrait of youth and friendship and relationships and their ugly or not-so-ugly aftermath. The kids are all right.

3

BILLIE JEANNE
IS NOT MY LOVER

Neal Pollack

OF ALL THE TRIVIAL REALITY SHOW MEMORIES that still cloud my brain as I drift into dreams or sit in my basement, stoned out of my gourd—any elimination of the first two seasons of *Survivor*, the time that whiny JAP won *The Amazing Race*, Kelly Osbourne's sixteenth birthday party, or Marcel getting jobbed by that overrated schmoozer Ilan on season two of *Top Chef*—only one still has the power to move and disturb me, many years and hundreds of wasted TV hours later: Billie Jeanne, the New York bartender from *Married by America*. I loved her. She was the only reality TV person I ever had a crush on, with the possible exception of Antonia from season four of *Top Chef*—a single mom of excellent character who would probably crack me like a walnut in her bare hands and discard me for someone far less neurotic.

Most reality women are either birdlike sorority phonies or overly made-up rubes from suburbs that used to be farm country. Billie Jeanne, on the other hand, was so wistful, so sweet, so *needy*, and so obviously damaged. She was the sad, beautiful woman you see at the café (the show was on at a time when I still occasionally went to cafés) reading bad poetry, and think, If only I could *reach* her with my *feelings*. She just wanted to be loved—to the point where she prepared herself for a televised life commitment to a used-car dealer named Tony. The guy was blandly, generically handsome; he looked like Sting would if he'd never been famous and had spent his entire life in Ohio. Tony had no personality at all, no original thoughts, no character. He was Everyman in the worst sense, that guy next to you on a Southwest Airlines puddle-jump playing solitaire on his PC. Tony couldn't handle Billie Jeanne's emotional typhoon. He couldn't match up with her swingin' New York lifestyle or histrionic gay best friend. I knew that he was totally wrong for her.

My suspicions were confirmed when she wafted down the aisle, looking radiant, streamlined, and perfect, a modern Marilyn Monroe, and he stood there all jittery like a dude in a second-tier beer commercial. He dumped her coldly and she fled in hysterics. The show's final shot, of Billie Jeanne hunched in a ball in the back corner of a closet, her face lit in negative like the last *Blair Witch* survivor while she screamed for the world to leave her alone, burned itself on my soul. In a reality world that feeds us bushels of "that man is a dog" finger-wagging and post-rose-ceremony crocodile tears, here we had true heartbreak trimmed to its very essence. Billie Jeanne was pure, innocent, and trusting. Reality-style love had absolutely

crushed her. She was a modern American tragedy, the victim of our competing desires for our true soul mate and the jackpot of celebrity without accomplishment. Her candle burned out long before her legend ever *started*. (And, yes, I did just paraphrase an Elton John song.) She inspired me like that. I was totally gay for Billie Jeanne.

I recently started to wonder what had become of Billie Jeanne. What had she been doing since getting Dumped by America? I missed her and I wanted to find out. Maybe she'd lost herself in alcohol and drugs, or become a nun, or been involved in some spectacular double suicide. I imagined her life as a *Grey Gardens* of delusion, Billie Jeanne as a fading beauty waiting for a prince who never came knocking. Oh, Billie Jeanne, what had we done to you?

• • •

Billie Jeanne, in her rawness and realness, was the best televised representation yet seen of an archetype that's haunted the margins, and sometimes the center, of my life since I hit puberty: the Crazy Girl. This type of person—starved for attention, pale, lovely, brilliant but unaccomplished, and either consciously or unconsciously manipulative—sparks my deepest wellspring of desire. When you're with a Crazy Girl, at any moment your life could be a carnival of sexual, intellectual, and spiritual gratification, or it could be a dirge of drunken late-night phone calls, hastily sent e-mails full of emotional recriminations, long, meaningful soppy glances, and subtle betrayals ending in alienation and unhappiness. That's what most of my relationships were like before I met my wife. Billie Jeanne made me nostalgic for pointless complications.

There's a difference, I should note, between the Crazy Girl and the Psychotic Girl. I'm not talking about Glenn Close in *Fatal Attraction*, Rebecca De Mornay in *The Hand That Rocks the Cradle*, or whichever Single White Female was totally barkers. Those characters, while compelling, don't appeal sexually or emotionally in the long term, and were obviously created by guys with problems. The Crazy Girl's torments are subtler, her revenge is quieter, her invasion of your soul more insidious.

Evidence of this type still abounds in our culture. John Edwards saw his public life end at the hands of a grown-up Crazy Girl, as she compared him favorably with the Mahatma and gave him an unwanted love child. In the second season of *30 Rock*, Alec Baldwin fell in with Crazy Girl guest star Jennifer Aniston, who gave him the best sex of his life accompanied by almost unimaginable emotional torment. These women have power, but it's a kind of Soviet-era nuclear power, with the continued threatening of a core meltdown.

We tend to encounter them most often in our twenties, though they appear at other times in our lifecycle as well. One Crazy Girl in particular, possibly the Craziest Girl, made me view Billie Jeanne with even deeper passion and sympathy. I met her when I was in my early twenties, and we were both bottom-feeders in the highly lucrative world of Chicago improv comedy. She had almost translucent skin, an ability with the folk guitar, and an Ivy League wit, making her an rara avis in a subculture where the majority of the women were wacky big-boobed blondes from Schaumburg. Most of the guys wanted to dink her, but I, as a professional writer and a putative intellect, got into the inner circle.

That afforded me the privilege of spending the night at her

house from time to time. We stayed up late—talking, soothing, and petting each other's hair. But she didn't allow me to go any further, because, she said, she didn't think we had much chemistry. I'd fall asleep next to her, our arms barely touching, my crotch ready to explode from the tension. At around three a.m., she'd take a deep, sighing breath, roll over onto an elbow, and start to gently brush my lips.

"This doesn't mean anything," she'd say.

"Of course not," I'd gasp.

But it meant everything, and we'd often make out half asleep until dawn. I'd feel so complete. Mid-morning, I'd wake up to a knock at the door. It would be one of her many other boyfriends, come to take her to brunch, or to a pickup co-ed basketball game. He and I would sit in her living room while she made us coffee and eye each other warily, like caged panthers, grunting a little, barely speaking, but knowing that we shared a little pit of total longing, deep in our souls, for our mutual friend.

We'd play that way for months, and then she'd stop returning my calls, and then she'd start again, telling me how much she needed me, that I was the only guy smart enough to converse with her about the topics she considered important, aware of the fact that if she name-dropped a guy she'd met who'd written for *The New Yorker*, I'd both know who the guy was and be competitive enough with him to feel jealous. She'd get the satisfaction of having a good conversation and making me feel miserable at the same time.

One night, I went to see her play a gig at some place in Chicago where people played gigs back then; there were a lot of women who'd hung out at the same clubs with Liz Phair and were trying to replicate her success. Because I hated myself, I

took a date along. Inevitably, the Crazy Girl saw me from the stage with my date and uncorked some half-thought-out insult toward me. I stood up, shouted, "FUCK YOU!" and stormed out of the theater. My date didn't appreciate this.

That, I determined, was the last time I'd ever see the Crazy Girl. I didn't need the hate and the manipulation. Crazy Girls made me tired. They didn't mix well with Melodramatic Guys.

Soon enough, I met my decidedly not-crazy future wife, and managed to make good on my Crazy Girl abstention vow. A while after that, I got a call from another of the Craziest Girl's pawns. She'd gone legitimately crazy, he said, and was locked up in a low-security home for Crazy Girls. Right now, he told me, she really needed people from her past to call her and make her feel better. So I did.

We talked for a while, mostly about the poetry she was reading. Finally she asked the question:

"So, are you seeing anybody?"

"I'm getting married next year," I said.

"Oh, that's too bad." She sighed. "I really think that when I get out of here, we can have a chance together."

My life would have gone very differently if I'd agreed.

• • •

The Crazy Girl, in the end, just wants security, love, and a settling of drama. But she lacks the gene that allows her to mellow with age. That's another reason this type compels: many of us have a deep desire to find something permanent and meaningful in a cruel, dirty, uncertain, and chaotic world, but the Crazy Girl is unable to fulfill that desire. That's why Billie Jeanne weeping on the floor of the closet struck such a resonant chord.

She'd hit existential bottom. We watched as the cruel random-ness of the universe enveloped her, and hoped we'd never see those depths ourselves. In the end, most of us want true love, or at least some sort of calm satisfaction instead of turbulent waters. We'd rather be Married by America than weeping in the back of a limo.

What, then, became of Billie Jeanne? I soon found out, along with everyone else. Few things dispirit a professional writer more than getting beaten to the punch by *Entertainment Weekly*, but there Billie Jeanne was, along with *Joe Millionaire*'s Evan Marriott and a bunch of people from shows I'd never watched, in a "What Were They Thinking?" feature in the summer of 2008. Oh, Billie Jeanne, you wouldn't even let me have my scoop! Here's what she had to say for herself:

"They told us we were gonna be famous, and I had a hell of a run for a while. I got a call from *Playboy* magazine, and I got a call from *Maxim*. I was on hold for a *Playboy* cover, but they did the Women of Starbucks instead. After the show, I moved to LA. I went on some really good auditions, but it wasn't for me. I came back to New York, where I met my husband."

The arc started promising. It looked like Billie Jeanne was going to bare all, but the Women of Starbucks usurped her. Then, in another example of the fickleness of celebrity, she got F-listed in LA's endless fame-whore derby. The story just screamed of crushed innocence. But then it took the saddest turn of all. She came back to New York and *met her husband*. That was it? Billie Jeanne got married and found peace less than three years after her public crushing? This wasn't fair. She was my tragic discarded queen. Crazy Girls weren't al-lowed to be *happy*.

Then again, I realized, this is what attracted me to Billie Jeanne, and her show, in the first place. For all of *Married by America*'s ridiculous trappings—the audience voting, the hot-tub parties, the cheesy adherence to the concept of true love forever—it felt real somehow. People meet their eternal life partners on the subway, or at bars, or at church. I met my wife through the newspaper personals. Is that really any more ridiculous than marrying someone you meet on a game show? Billie Jeanne wanted to get Married by America. When that didn't work out, she sought to get married by more conventional methods, and then she did.

Her untragic fate illumines what most of us face in life. It's ordinary, boring, and banal. A few people are destined to follow an exceptional path, or to have things collapse for them absolutely, but most of us don't experience such highs and lows. A trip to your high school or college reunion puts the lie to the myth that we were all born to be special. Simply, we're not. We marry, have kids, get old, shit the bed, and die. Our reality TV stars may get the brief illusion of transcendence. They take a few Hollywood meetings and occasionally get cast in a *Road Rules* reunion. In the end, though, they're just like the rest of us, and anyone who was on *Married by America* is more like the rest of us than most.

4

THE CUTTING CREW

Jancee Dunn

IT HAPPENED THE WAY THESE THINGS OFTEN DO. I was drifting around my Brooklyn apartment on a Sunday afternoon, putting off a writing assignment. I had already given the place a procrastination cleaning so compulsively thorough that at one point I found myself consolidating two boxes of bandages into one more streamlined package. And so I turned on the television—a no-no among my writer cronies, who argue that daytime TV begins a dissolute spiral downward. Writers are a vulnerable population of clammy, sweatpants-clad hermits, and while other groups are quite capable of "just turning on *The View* for ten minutes," we are not. For me, a quick check-in with Barbara and the gang would lead to a twenty-two-hour sloth-a-thon capped by a five a.m. showing of *Turner & Hooch*. Then I'd start drinking. Then I'd start doing drugs.

So it was with extreme trepidation that I reached for the remote, but I was desperate not to work. I flicked uninterestedly through dozens of channels before landing on Bravo, which was running a marathon of the 2004 first season of *Project Runway*. I sighed. I was never a fan of reality TV, never able to join in the watercooler chat about the latest episode of *American Idol*. My grannyish viewing preferences tilted toward cozy mystery series on PBS starring elderly but plucky detectives.

Five minutes into *Project Runway*, I put the remote down. An hour later, I had taken a pillow from my bed and tucked it under my back for a more comfortable viewing position on the couch. Three hours later, I was absently shoving a box of pizza rolls into my toaster oven with my eyes fastened to the screen as I rooted for contestant Jay McCarroll to win. Around midnight, I got my wish.

The premise of the show is simple: a cutthroat group of contestants competes to create a garment, usually with alarmingly limited time and materials, to be presented at a runway show at the end of the program. Every episode presents a different design challenge, ranging from nutty (an outfit made with items from the grocery store) to inspired (fashioning a new ensemble from the clothes on contestants' backs). Up until the sixth season, taping took place in New York City—to bang the point home there are many, many loving shots of massing pigeons and yellow taxicabs—with much of the action taking place at Parsons The New School for Design, where designers take over a workroom.

German glamazon Heidi Klum—("As you know in fashion: one day you are in; the next, you are out.") whose deliciously chilly Teutonic parting shot to each exiting contestant is an

auf Wiedersehen followed by a double air kiss—is a perfect host. Her fellow judges nicely round out the mix: designer Michael Kors, former *Elle* editor-at-large Nina Garcia, and a guest judge along the lines of Victoria Beckham. Kors's sense of humor mitigates the sting of his criticism ("Hel-LO! Slutty, slutty, slutty!"), while Garcia, unfairly labeled as too tough, brings an intelligent, high-fashion perspective to the proceedings ("Don't bore me").

Oh, how do I love thee, *Project Runway*? Let me count the ways. The heart of the show is witty, cultured Tim Gunn, former chair of fashion design at Parsons (and now chief creative officer of Liz Claiborne). One of the highlights is his visit to the workroom to inspect the designs-in-progress. He frowns in concentration, one hand on his chin. "Talk to me," he'll say after a long silence, and the contestant ramblingly explains his or her vision. If he's pleased, he says "Carry on." Less skilled contestants get a diplomatic "I'm concerned."

Much has been made of Gunn's extensive vocabulary and liberal use of words such as "constructivist" and "egregious" and "amorphous." "Why is there so much consternation and Sturm und Drang?" he'll ask a blank-faced designer. Gunn's eloquence helps to tamp down that sheepish self-loathing that reality television can elicit—the same tawdry shame that waits at the grease-soaked bottom of a McDonald's bag after a binge.

I'm desperate to be Tim Gunn's friend, and fantasize about meeting him at the Neue Galerie uptown for Viennese coffees at Café Sabarsky before taking a stroll in Central Park, where we discuss art, literature, *life*. Alternatively, he might summon me to an elegant little pre-opera supper at his apartment before we attend a performance of *La Gioconda* together at the Met,

where we discreetly squeeze each other's arms during onstage moments of high emotion.

There are many other soothing constants that I look forward to each week, like the pitiless tradition of tossing out an extraneous model during the first few minutes of the show (they also compete for a spread in *Elle* magazine) just to whet the audience's bloodlust. *Auf wiedersehen,* Tatiana!

I love the endless, brazen product placement, as Gunn says straightfacedly, *You-have-an-hour-to-send-models-to-the-TRESemmé-hair-salon-and-the-L'Oéal-Paris-makeup-room-and-please-borrow-generously-from-the-Bluefly .com-accessory-wall.* I adore the way the most minor setback is blown to *Titanic* proportions (Tim to season five contestant Keith: "Your model, Runa, had to drop out." Cue dramatic music and a tight closeup of a white-faced Keith, blind with shock as he struggles to absorb this telegram delivered straight . . . from . . . Hell).

And who can resist the brash, flamboyant, high-octane contestants, with their killer competitiveness, their unvarnished ambition? If a designer is praised by the judges during the fashion-show segment, the camera will gleefully cut to another designer who is grimacing with disgust and naked hostility. I rejoice in the genuine anger and indignation the contestants display when they are eliminated, leaving with the requisite, defiant "you haven't heard the last of me" quote. They do everything but shake their fists at the camera. Frankly, I'm shocked that no one has tried to burn Parsons down. Never, ever will they admit to an inferior creation that actually deserved to be cut.

So many gaudy, glitzy, eccentric fabulons! Campy costume designer Chris March, passive-aggressive schemer Wendy

Pepper, spacey artist Elisa Jimenez (who used her own saliva to measure her clothing), glamorous, poised Austin Scarlett (yes, his real name) with his cravats and perfectly arched eyebrows. Inevitably, there is a bemused straight guy thrown into the group who holds himself slightly apart from his more unabashedly gay competitors. (Kevin Christiana was season four's bemused straight guy, given to comments like "There's too much drama because there's too many queens around," although soon enough he too was dispensing snippy comments about his fellow contestants for the cameras.)

And, inevitably, there is a tough contestant who isn't afraid to verbally tussle with the others—my favorite being season three's flame-haired paragon of cool confidence, Laura Bennett, the sole grownup on the show, fortyish and pregnant with her sixth child and *not in the mood for any crap*. Being timid myself, and reluctant to start even the mildest confrontation in New York City lest I get stabbed, I cackled every time she snapped at someone to shut up.

But the apex of *Project Runway* is the moment that the contestants get down to work. The cameras are forgotten (well, almost forgotten) as they become utterly absorbed in a frenzy of stitching and snipping and fitting. This is the part of the show that many viewers cite to justify their habit, because it lulls you into thinking that this is a more highbrow endeavor than your average reality show. No implants! No hot tubs! See? Everyone is *creating something*. It won a Peabody!

As a writer who works alone, I burn with envy as I witness the designers in action, because they have the best of both worlds: the camaraderie and feedback of a group and the glory of showing off their individual creations. I will never have

both. At this point in my career, my ego won't allow me to work in an office and surrender the spotlight. On the other hand, my "office mates" are my two cats, and I have found myself more than once dementedly saying to them, *Well! Let's see what the postman brought us* or *Hmm, what should I have for lunch today? I'll bet you guys vote for tuna salad, right?* On some days, I'm one step away from hosting a Cat Tea Party, so I'd happily move into the workroom and brave the backbiting.

Aside from watching the contestants at work, another key element of the show's appeal is the kaleidoscope parade of outfits sported by most of the designers, particularly the ones who are in their early twenties. They dress the way I wish more New Yorkers did. Every person in New York looks like a demure fashion editor now, so I celebrate the contestants' every pillbox hat, every canary-yellow strip of eye shadow, each pair of stunningly impractical chartreuse shoes with a five-inch mirrored heel. New Yorkers, of all people, have become entirely too beige—and unfortunately, I include myself in that category.

When I first came to New York, aflame with the same energy the contestants have, I wore the most preposterous outfits in the world, and I'm glad I did. After I joined the staff of *Rolling Stone* in 1989, my first order of business was to run out and purchase three pairs of leather pants: black, brown, and white. White leather pants! Did I think I was a member of Earth, Wind & Fire? Naturally, I wore them with a sleeveless purple shirt trimmed in feathers. As a twenty-two-year-old New Yorker, you have a God-given right to look ridiculous as you clomp down the street in a white vintage slip and combat boots.

I fell on the city like a starving rat on a moldy ham sandwich, rushing to discover new bars every night, spending

weekends combing through various neighborhoods, ducking into thrift stores and museums and cafés. The show deftly captures the giddy excitement of being a recent arriviste in the city, hoping to be somebody else, and fast.

Which leads me to my very favorite part of the series. As the finale nears and competitors are whittled to a handful, we are treated to a more rounded portrait of them. Earlier in the season, designers may rattle off a quick biography for the camera in between running to the Hershey's store in Times Square to fashion a dress out of candy, but beyond that, not much information is given on their backgrounds. This is remedied in the last few episodes, when the remaining three or four contestants are handed eight thousand dollars and given a dozen weeks to complete a twelve-piece look to be shown at New York Fashion Week in Bryant Park. Each of them tapes an extended segment in which they talk about their beginnings. Then, after they commence work on their collections, Tim Gunn himself pays a visit to their homes to check their progress.

Gunn is, as always, gracious and kind, but somehow his visits are exceedingly awkward as he stands, cheery and dapper and slightly hesitant, at the doorstep. The moment when he is invited in is so sweetly poignant, because it is then that we see the designer's roots peeking out from beneath the wacky headgear. The place where most of these sophisticated hipsters grew up is often markedly different from their carefully cultivated, glamorous personas: there is the ordinary-looking family, uncomfortable in front of the camera and unsure of what to say; there is the drab sofa where Gunn sits briefly before heading off.

I had assumed that season four's Jillian Lewis, so urbane on

the show, was an Upper East Side private-school girl, but instead she was a Parsons grad who hailed from a modest house in the small town of Selden, Long Island. First season winner Jay McCarroll, he of the pointed wit and flamboyant dress, grew up in the tiny mountain town of Lehman, Pennsylvania, the youngest of six kids. His dad was a bricklayer, and the family shopped at Sears. And whippet-thin, black-clad season four winner Christian Siriano may have looked like the bastard child of Ron Wood and French *Vogue* editor Carine Roitfeld, but in the end, he had the same comfortingly pedestrian relatives that most of us do.

In an instant it's clear how thoroughly these designers have reinvented themselves, how they carefully honed a new persona until one day, they were the person they always wanted to be. I did it, too. When I took the New Jersey Transit bus into the city in 1989 to interview for a job at *Rolling Stone*, I had a Jersey girl perm, long red nails, heavy Color Me Beautiful makeup, and an Ann Taylor power suit I had borrowed from my mom. As I waited in the lobby, I realized with dismay that I looked utterly different from the stylish employees breezing into the office. After I landed the job—to my astonishment—I took careful note of the city girls around me. I lost the perm. I bought good shoes. Slowly, slowly, I blotted out that scraggly Jersey girl and transformed her into someone else. If you looked at me now, you'd see a confident urbanite. Some days, I almost believe it myself.

5

SHOW BOAT

Toby Young

"DON'T DO IT," SAID MY WIFE. "They'll make you look like a complete prat."

I'd asked her advice about whether to participate in a British reality show at the beginning of 2004 called *The Other Boat Race*. According to the e-mail I'd received from the BBC, I would be one of half a dozen fat, middle-aged Oxford graduates competing against an equally out-of-shape Cambridge team to mark the 175th anniversary of the Boat Race, an annual institution in the United Kingdom in which two teams from Oxford and Cambridge compete against each other. To train us for the big day, in which we'd race along the Thames, the BBC would enlist the help of various Olympic rowers, including the five-time gold medal winner Sir Steve Redgrave. The highlight would be a one-week, residential boot camp—or "boat camp"

as the Beeb wittily described it—in which we'd be filmed huffing and puffing as the Olympians put us through our paces.

I knew Caroline was right—of course I'd end up looking like a prat—but there were various arguments in its favor. For one thing, there was the $20,000 payment—nothing to sniff at now that I had a family to support. Then there was the fitness factor. I was weighing in at 185 pounds, which, for a man of my age and height, was "clinically obese." It also appealed to the schoolboy in me. How often do you get the chance to be trained by Olympic athletes? It was as if a group of gods had come down from Mount Olympus and offered to teach a bunch of mortals how to fly.

But above all it was an opportunity to appear in a reality show.

This wasn't the first time the possibility had come up. For instance, in October 2002 I was contacted by a woman claiming to be from a production company called Endemol to ask if I was interested in appearing in the British version of *Celebrity Big Brother*. Naturally, I assumed it was a practical joke being played by one of my friends. It wasn't until I received a formal letter on printed stationery the following day that my doubts were laid to rest. Incredibly, the offer seemed genuine. They wanted me to be one of six or seven "housemates" who would compete against one another later that year.

My first thought was: Why me? I might have attracted a little bit of notoriety in connection with *How to Lose Friends & Alienate People,* a book I'd written about trying (and failing) to take Manhattan, but I was hardly a household name. This would surely be held against me in the yellow press. I imagined various articles complaining about the fact that such

a total nonentity had been selected to take part in a program supposedly featuring "celebrities." I would end up being ranked somewhere below Kato Kaelin in the micro-celebrity pecking order: I'd become famous for *not* being famous.

Shortly afterward, I was offered another reality show—only this one was even less appealing. It was called *Celebrity Wife Swap,* and the woman I would have to exchange Caroline for was Jade Goody.

For the uninitiated, Jade was a contestant on the third British series of *Big Brother* whose main claim to fame used to be that she was . . . well, not very bright. Here are a few of the things she said on the program:

> "Where is East Angular? Is it abroad?"
>
> "Rio de Janeiro—that's a person."
>
> "Saddam Hussein—that's a boxer."
>
> "A ferret is a bird."
>
> "Who is Heinzstein?"
>
> "Mother Teresa is from Germany."
>
> "Sherlock Holmes invented toilets."
>
> "What's a sparagus? Do you grow it?"
>
> "You see those things [on peacocks' feathers]? Don't think I'm being daft . . . but them things that look like eyes, are they their real eyes?"
>
> "Jonny, I'm not being tictactical here."
>
> "They were trying to use me as an escape goat."
>
> "Do they speak Portuganese in Portugal? I thought Portugal was in Spain."

Jade subsequently got cancer—a fact she learned while participating in the Indian version of *Big Brother*—and was instantly transformed from a standing joke into a national treasure. Indeed, her last months were played out in another reality show—this one about her life—and there was something weirdly impressive about the total shamelessness with which she exploited the genre. What Oprah is to afternoon talk shows, Jade was to reality TV—and she made a small fortune.

But it wasn't just Jade I was worried about when it came to *Celebrity Wife Swap*. Her then boyfriend was an attractive, twenty-three-year-old television host called Jeff Brazier. He was precisely the sort of cheeky Cockney geezer that Caroline had a weakness for. *What if something actually happened between them?* I could envisage a scenario in which I woke up the day after *Celebrity Wife Swap* had been broadcast to discover two dozen reporters camped on my doorstep, all of them wanting to know how it felt to be cuckolded on national television. Front and center would be the *News of the World*, having concluded a six-figure deal with Caroline courtesy of her newly appointed publicity agent. The most I could hope for would be an appearance on a special edition of *Jerry Springer* in which half a dozen men who'd been betrayed by their partners on reality shows would have a chance to confront them. It would very quickly spiral out of control and Jeff would end up flooring me with a right hook. I would officially become Britain's biggest loser. No woman would ever go out with me again.

Still, the prospect of appearing on a reality show was mighty tempting. The emergence of "reality" as an all-conquering television genre—both in Britain and in America—was one of the biggest media stories of the decade, and as a journalist I

longed for an opportunity to get a look at this phenomenon up close. In contrast to *Celebrity Wife Swap* and *Celebrity Big Brother*, *The Other Boat Race* felt relatively safe—not least because it didn't have the word "Celebrity" in the title. I'd be one of sixteen participants, so I'd hardly be in the spotlight, and everyone involved would have gone to either Oxford or Cambridge. No doubt the people watching would dismiss us as a bunch of wankers, but at least we wouldn't be thought of as a bunch of *stupid* wankers. And rowing is held in such high regard by the British public that our involvement in the show would be understandable. Who wouldn't want to be taught how to row by Britain's only athletes to consistently win gold medals at the Olympics?

So I said yes. In spite of the fact that the survival time in the river Thames in the middle of winter is under four minutes, *The Other Boat Race* seemed comparatively risk-free.

• • •

"Put your back into it, lad. *Come on.* Give it some welly."

The speaker was Tim Foster, a David Beckham lookalike who had won a gold medal at the Sydney Olympics. It was day two of the show, and I'd been separated from my teammates and stuck in a coxless four with two ex-Olympians and an Oxford rowing champ. As I struggled to keep up, Foster drew alongside on a launch and started shouting at me through a megaphone. It was like trying to play doubles with Björn Borg, Jimmy Connors, and Stefan Edberg, while McEnroe made wisecracks on the sidelines.

I couldn't help thinking I'd made a terrible mistake. Wouldn't I just look completely ridiculous in contrast to these

hulking great athletes? Any sane person watching the show would think: "What are these national heroes doing in a boat with a fat bald bloke?" As if to ram the point home, the boat was so unbalanced by the fact that I was on one side of it that we ended up going round in circles.

Still, at least I wasn't doing significantly worse than the other "civilians" on my team. For one thing, we were all far too small to excel in this particular sport. With the exception of Jonathan Aitken, a former Conservative member of Parliament who stood six foot three, everyone on the Oxford team was five-eight or under. As Richard Herring, one of my teammates, pointed out, rowing boats are normally crewed by giants and coxed by midgets. Our boat was being coxed by a giant—Aitken—and crewed by midgets.

In addition, five of the people in the eight-man Oxford boat were asthmatics. I discovered this on the first day when one of our coaches made us race a team of sixteen-year-olds from a nearby school. Afterward, as we were all bent double on the riverbank, five of my crewmates pulled out inhalers and started puffing away. I immediately asked one of the producers if I could approach Ventolin about a possible sponsorship deal, but he said it would be against BBC rules.

Nevertheless, provided we all stayed in the boat, our humiliation would be limited to not being able to row. It was only when the BBC filmed us out of the boat that things got a little sticky.

For instance, the producers discovered that I knew a member of the Cambridge team—a fellow journalist named Grub Smith—and they decided it would be fun to exaggerate the rivalry between us. To that end, they asked if they could film us

playing golf and in a moment of madness I agreed. Needless to say, I made a complete dog's dinner of my first tee shot and the ball landed at the feet of a cameraman standing about ten yards away. He immediately dropped to his haunches and followed the progress of the ball as it dribbled to a halt. Rain forced us to abandon play after six holes, by which time Grub was two under, while I was already in double digits.

However, that wasn't the most embarrassing episode in the eight-week shoot. That occurred when my teammates and I spent the day in the company of Sir Steve Redgrave, one of only four Olympians in history to win gold medals at five consecutive Games.

"So, Sir Steve," I said, trying to break the ice, "how d'you think the England squad is going to fare in Athens without you?" This was a reference to the fact that he'd announced his retirement at the 2000 Olympic Games and wouldn't be competing in 2004.

He gave me a blank look. "Which England squad?"

"The, er, English Olympic rowing squad."

Beat.

"Do you mean the *British* squad?"

"Sorry," I said, slapping my forehead. "I'm an idiot."

Later, as we reviewed grainy video footage of Sir Steve's Olympic victories, I attempted to claw my way back into his good books by pointing out Martin Cross, one of the Oxford team's coaches, sitting alongside him when he won his first gold in 1984.

"Isn't that Martin in the stern?" I asked, indicating a shaggy-haired young man at the front of the boat.

"That's the bow," he said, looking at me in the same way he looked at the Germans when he and Matthew Pinsent left them in their wake at Barcelona.

Needless to say, a BBC cameraman was on hand to capture both of these exchanges.

• • •

Why does anyone agree to appear on a reality show? The obvious answer is because they want to be famous—but why? Is it simply a desire for status? Celebrities live in the grandest houses, dictate the latest fashions, and enjoy unlimited sexual opportunities—but even this description of the perks of being a celeb is a rationalization. The desire for fame is more primordial than that. It's about the longing for recognition, the need to stand out in the crowd.

I have to confess, I'm as pathetic as the next man in my craving for attention. At some prerational level I, too, think I'll never be fully actualized until I'm a celebrity. More than this, I believe that once I've crossed that Rubicon I'll achieve a kind of immortality. This must be at the root of why anyone wants to be famous: it's a way of cheating death.

But I'm enough of a student of the subject to know that fame, as an end in itself, doesn't have the same currency it once did. Scarcely a day passes without a hand-wringing article appearing in the press about how fame and celebrity have become the dominant values of our time, when, in fact, almost the opposite is the case. In the first decade of the twenty-first century—thanks, in part, to the phenomenal success of programs like *Survivor*—we've witnessed the gradual separation of fame and status. These days, being well known doesn't auto-

matically ensure high social standing (let alone immortality). You can be famous and still be a loser: a famous loser. In Britain, the best example is probably James Hewitt, the guardsman who had an affair with Princess Diana, but there are countless others.

It doesn't really make sense to call James Hewitt a "celebrity." I mean, what does he have in common with Brad Pitt or Tom Cruise? There are so many different varieties of fame these days we need to develop a whole new vocabulary to describe them. At the moment, the best we can do is rank celebrities according to whether they're A-list, B-list, etc. But even if we use every letter of the alphabet that still gives us only twenty-six different types. That's surely not enough. Eskimos have forty-seven different words for snow. Shouldn't we have forty-seven words for celebrity?

Then there's the issue of duration. All things being equal, being famous is probably preferable to not being famous, but you better make damn sure you remain in the spotlight for longer than fifteen minutes. Unlike love, to have had fame and lost it is worse than never having had it at all. It's like the argument about why you should never take a one-off opportunity to fly first class: once you've turned left, you'll never want to turn right again. Sometimes it's better not to know what you're missing.

It's not just reality stars who have to worry about this. Even some A-list celebrities have the shelf life of milk. Egged on by the tabloids, the public appear to have an insatiable appetite for seeing the famous toppled from their thrones. Being in the public eye is a bit like being in jail: one wrong move and all your privileges are taken away.

Why is this? One approach to answering that question is to look at the life of Lord Byron, the first modern celebrity. Byron was an overnight sensation, becoming famous at the age of twenty-four with the appearance of *Childe Harold's Pilgrimage*. For the next three years, every door was open to him. He was a guest at all the great Whig houses of the period and lionized by London's leading hostesses. Then, almost as quickly as he rose to fame, he suddenly fell from grace—a victim of the same *build 'em up and knock 'em down* syndrome that's so familiar to us today.

Byron attributed his demise to "envy, jealousy, and all uncharitableness," but is that accurate? To see celebrities as just another privileged class, subject to the same animosities as any other well-off group, doesn't do justice to the complexity of people's feelings toward them. Clark Gable once remarked to David Niven that, when it came to the contract between a star and his public, the public had read the small print and the star hadn't. All it took was one tiny violation and the adoring crowds turned into a baying mob. "So, when we get knocked off by gangsters . . . or get hooked on booze or dope or get ourselves thrown out of business because of scandals or because we just get old, that's the payoff and the public feels satisfied," said Gable. "Yeah, it's a good idea to read that small print."

Perhaps the best place to seek an explanation for why fans have a tendency to destroy their idols is *The Golden Bough*, J. G. Frazer's comparative study of magic and religion. In Books II and III, titled "Killing the God" and "The Scapegoat," he discusses various primitive religions in which individuals who are believed to be the living embodiment of divine beings are first worshipped, then put to death by their followers.

According to Frazer, human sacrifices such as this were designed to strengthen and revitalize the god or goddess that the victim was impersonating. The savages who performed these rituals weren't actually trying to kill their gods; rather, by murdering their human proxies they were seeking to preserve the immortality of their deities. Indeed, Frazer maintained that the Easter celebration of the death and resurrection of Christ had its origin in these primitive rituals.

There's one passage in particular in *The Golden Bough* that should serve as a warning to anyone tempted to appear on a reality show. According to Frazer, some divine kings managed to avoid being killed by their followers by nominating a proxy to be put to death in their stead. The princes of Malabar, for instance, delegated supreme power to one of their subjects, allowed him to lord it over them for five years, then sat back and watched as the man's head was chopped off. Clearly, the celebrities created by reality television programs are the modern-day equivalents of these chumps. Nonentities are plucked from the hoi polloi, allowed to enjoy the privileges of fame for a few precious years, and then ritually sacrificed in the tabloids. In this way, the public's bloodlust is satisfied and proper celebrities are able to hang on to their own privileged status for a little bit longer.

• • •

As race day approached on *The Other Boat Race*, I came down with a bad case of the jitters. We'd raced against at least half a dozen other crews at this stage, not just the sixteen-year-olds, and they'd all beaten us, but that wasn't my chief concern. My big worry was that I had become so discombobulated on every

single one of these occasions that I had come off my seat. The upshot was that I'd spent several minutes of each race flailing around, desperately trying to get back on my slider as it careered back and forth in time with the motion of the boat. It was a bit like trying to remount a mechanical bull when it was at full tilt.

Still, at least I'd come up with a solution to this problem. Just before the start of the race I was planning to superglue myself to the seat. Unless the boat capsized, I would probably be okay.

No such easy solution presented itself to the problem of "catching a crab." This is rowing-speak for putting your oar in at the wrong angle and getting it stuck in the forward position. Due to the momentum of the boat, once you've caught a crab it's almost impossible to rectify the situation. But you can't just sit there and do nothing, since your oar is effectively acting as a brake. The correct thing to do is detach your oar from its rigger, toss it in the water, then throw yourself in after it. To remain in the boat, even if you've successfully detached your oar, is to add a good deal of unnecessary weight. The least you can do is leap over the side.

The trouble was, I didn't know if I'd have the guts to do this—not least because it would involve wriggling out of my tracksuit bottoms, which would still be superglued to my seat. A few yards behind the Oxford and Cambridge boats would be a huge flotilla of vessels containing race officials, interested parties, spectators, and, of course, numerous BBC camera crews. Even if I managed not to be hit by one of them, I would then be faced with the problem of how to get out of the water in under four minutes while simultaneously avoiding being filmed on the riverbank in my tighty-whities.

The hardest thing about being in a reality show, I discovered, is not to appear too self-conscious. At some point in their lives, nearly everyone has labored under the impression that they're starring in their own private movie—and when you're in a reality show that illusion turns out to be true. Your every move *is* being watched. There *are* secret cameras concealed in that tree. The standard advice is *Just be yourself,* but it's extremely hard to relax and act normally when you're concentrating so hard on not picking your nose or scratching your balls. Appearing in *The Other Boat Race* was less like the fulfilment of a lifelong ambition than an extremely demanding eight-week test. For perhaps the first time in my life, I didn't want to make a fool of myself.

In the event, I managed to hold my own in the boat and—miracle of miracles—the Oxford team won. In fairness to the Cambridge team, this wasn't because we were better rowers than they. Rather, it was because Tim Foster had the good sense to tape up the sides of our boat so water couldn't get in. The race took place on a typically blustery winter's day and the upshot was that the Cambridge boat took on several gallons of water as it inched along the Thames, giving the crew a huge weight disadvantage. Still, we didn't know this at the time and winning felt incredibly good. As we passed the finish line I could hear the sound of the BBC commentator's voice over the public address system: ". . . and here comes Gandalf, coxing his hobbits to victory."

My anxiety about the effect that appearing in *The Other Boat Race* would have on my career—would I become a D-list celebrity, only to be tossed to the tabloid wolves?—proved laughably unfounded. It was broadcast on BBC3, not one of the

major channels, and was watched by so few people that it scored a zero rating. The only person who saw it, apparently, was Sam Wollaston, the *Guardian*'s TV critic. "I'm sure for the people taking part it's quite good fun, and all sorts of personal goals are being achieved," he wrote. "But, like the real boat race, it's not one to watch. A load of rowlocks in fact."

6

THE BITING HAND

Will Leitch

CESAR MILLAN, the eponymous Dog Whisperer, has a technique he uses to keep unruly dogs in line on his show. He calls it "curbing aggression," but to me it just looks like a neat trick. When a dog is attacking, about to attack, or generally doing something he's not supposed to, Millan will grab the dog on the shoulder and squeeze while making a little *tsst* sound. As Malcolm Gladwell observed in *The New Yorker,* Millan calls this gesture a *bite.* "My hand is the mouth," he told Gladwell. "My fingers are the teeth." Without fail, it calms the dog immediately. According to Millan, he's making sure the dog falls into a "submissive position."

In the land of the Dog Whisperer, there's no problem in the world that isn't caused by insecurity, discomfort, and alpha male territorialism. And there's no problem that can't be solved

by a calm setting of boundaries, by informing the offender just who is in charge. Cesar Millan is a problem-solver. Cesar Millan brings order to chaos. Cesar Millan can save families by making them his own.

The format of every episode of the National Geographic Channel's wildly popular *Dog Whisperer* is the same. We meet the beleaguered owner of a monstrous dog, a dog that's biting the neighbors, tearing up the furniture, and urinating where he isn't supposed to—pretty much everything many of us did nightly in college. The producers amp this section of the show to the hilt, showing the dog barking and biting in super-slow motion, making him look like a shark leaping out of the water to attack a hapless bikinied swimmer. Sometimes they even overexpose the video to make it look especially evil, like local newscasts when they warn of child predators just around the corner from your home. *It could happen to you.*

Faced with such chaos, the owner will look plaintively into the camera and drop vague hints about canine homicide. "I don't want to get rid of Fluffy," they'll say, "but I'm worried about my child/other, smaller dog/nice furniture/standing in the community. I just don't feel like I have any other choice but to send Fluffy back to the pound." Of course, the owners know they have another choice: they're talking into a TV camera, after all. They know help is right around the corner—in the form of the Dog Whisperer.

Cesar to the rescue. He shows up at the house and asks the owners to explain Fluffy's behavior. Often, before they even have a chance, Fluffy pees or barks or bites or does whatever Fluffy has been doing to bring Cesar there in the first place. The owner looks at Cesar with a shrug: *See what I'm talking*

about? And then Cesar asks the owner to leave. It's time for some Cesar-Dog communing.

Cesar calls it Letting the Dog Know Who's in Charge, but mostly it looks like he's kicking the dog's ass. This is where the "biting" comes in—repeatedly. Without fail, Cesar calms the mutt down, and, within thirty-five seconds of National Geographic Channel screen time, Fluffy is licking Cesar and happily fetching whatever Cesar tosses him. ("To a dog, you're a giant walking tennis ball," Cesar says.)

Then the owners come back in the room—and Fluffy freaks the fuck out again. They look at Cesar, who blames them for not understanding the dog. Then he says it's time for Fluffy to come with him. He needs to be deprogrammed. He needs, for a little while, to join a family that understands him.

Thus: the Dog Psychology Center. Set up in a converted auto mechanic's shop in the industrial zone of South Central Los Angeles, this is where Cesar's dogs live.

This is a family I can handle. This is the family I want.

• • •

My sister and I grew up with my happy, well-adjusted parents in Mattoon, a tiny central Illinois town surrounded by other tiny central Illinois towns. When adulthood came, she moved to San Francisco. I moved to New York City. My mother jokes that we just went in opposite directions until we hit water.

In high school, I didn't drink, never stayed out past curfew, made the honor roll, and played on a conference championship baseball team. My younger sister had several experiments with drugs—all successful—and relationships with several tattooed boyfriends who referred to themselves by one-letter

names, (J, for example, or Rad K)—which were less successful. She was generally the holy terror that teenage girls are supposed to be.

My natural instinct is toward peace and calm: I just don't want any trouble. My sister is the opposite. Chaos is the void she must fill, and if there's no void available she'll blast one open. This is impossible for me to handle, and I suspect that my smug self-satisfied piety—*well,* I *follow all the rules*—only provokes her to act out further. This bothers me a lot more than it does other people. When my sister does something outrageous or loud and garish and embarrassing, everyone else just laughs: that's just Jill being Jill. Meanwhile, I'm hiding under something, seething and shaking.

Yes, she's a lot more fun than I am.

I love my sister dearly, but there are times when I believe God put us both on earth as a cosmic joke on my parents. My father is an electrician, my mother a nurse—they have regular human jobs in the Midwest that tether us and themselves to the practical planet. They are normal people. So, just to make sure their lives weren't easy, God gave them children who were exact temperamental opposites. When we were kids, my parents called a babysitter who was one year older than Jill—and four years younger than me. She wasn't there for me; she was there just to keep my sister occupied.

Jill and I are as close as any siblings can be; we understand each other and our family in a way no one else will ever be able to approach. She's the one I call when matters fall apart, the one I'd conquer Sparta to keep safe. In the interest of our respective sanities, however, it's best that we to live on opposite sides of the country. We chat on the phone, e-mail regularly,

comment on each other's Facebook updates. Nice and careful. Nice and easy. Enough to keep my order out of her chaos and vice versa. *Until we hit water.*

At the age of thirty-four, I have been engaged three times. (I'm currently in my third.) The reasons the first two ended were wildly divergent (the first was when I was twenty-one, and the decision was hers; the second was when I was thirty, and the decision was mine), but they both ended. I'm engaged now to a wonderful woman, whom my family and my friends adore, and yet I know what they're all thinking: *We'll believe it when we see it.* I live in New York City, one of the few places left in America where being single at thirty-four is the rule rather than the exception. My father flew to New York to attend a party for the release of my last book, and he marveled at the range of ages of my friends. Some were twenty-one. Some were fifty-eight. And they were all in the same social circle. In New York, you can be twenty-eight forever. You have to grow up . . . but you don't have to grow up *that* much. Twenty-eight: That's where you can stay. Where there's not much risk of trouble.

• • •

As for Jill, until recently she'd been dating the same man for six years out in Oakland. It'd be safe to call them the Sid and Nancy of suburban Oakland arugula homeowners. Their relationship had always been passionate and tumultuous, and mostly terrifying to the rest of the family—especially me. He was a tall, attractive fella, successful, charming when he needed to be. He could have chosen to be with all kinds of dull yes-women who would have blandly devoted their lives to being ideal perfect wives, as long as there was a walk-in shoe

closet, but he didn't: he chose the whirlwind Tasmanian devil that is my sister. (That he would make this decision, this leap, this *risk*, was my favorite thing about him.) They broke up six or seven times, usually just for a few hours, and there were affairs and drama and shattered china and red welts and angry text messages and public affection and all things I couldn't fathom. They would fight constantly, and fervently, in a way that baffled me: my relationships had always been placid, refined affairs. I didn't like to so much as publicly disagree with the women I dated. That kind of thing was to be dealt with later, at home, in a controlled environment. Not Jill and her Sid. They'd scream at each other at dinner and then be making out in the corner by the end of the night. They were bad with money, terrible at keeping to a schedule, completely unrealistic with their expectations for the real world, and totally, awesomely in love.

It worked for them. I couldn't imagine it. But it worked.

And then, suddenly, it didn't.

• • •

The leader of the Dog Psychology Center is Daddy. Daddy is a fourteen-year-old pit bull with arthritis, cancer, and the rather awesome circumstance of having once been owned by the rapper Redman. Daddy rules everything. Daddy is in charge. Daddy is so important to the Dog Psychology Center that he'll make house calls with Cesar, when a dog is flying unusually far out of control.

Daddy is calm, sedate, and measured. He was one of Cesar's more difficult projects, but once Cesar whispered to him, their silent dance of back-and-forth alpha male tango, he became

the leader of the pack. I don't mean that in a clichéd, doo-wop, *vroom vrooooom* type of way. I mean that the forty-seven dogs at the Dog Psychology Center are a pack. Daddy is their leader. And you do not fuck with Daddy.

At the Dog Psychology Center, Cesar's three-step training process is paramount: "Exercise, discipline, then affection." It's really that simple.

Exercise: Run the shit out of them until they're too tired to do anything but lie down.

Discipline: When they want to lie down, you don't let them, because you must show them you are in charge.

Affection: When they have ceded to your demands—because you know what is best, because you will protect them, because you will keep them safe—you may pet them and give them a treat.

And then they will never leave you and they will never be hurt.

Daddy absorbed this lesson at the highest level—in Scientology, he would be the one who rose to the utmost apex of Thetans—and now he is in charge. But he is a peaceful, solemn charge, his (dare I say?) hangdog expression almost John Wayneish in its authority, his force to be used sparingly and only when absolutely necessary. He is the drill sergeant everyone respects. He is Cesar's consigliere.

Oh, what fun they have at the Dog Psychology Center. Gladwell, in his piece, calls it "the most peaceful prison yard in all of California," but that's selling it short. It's one big warm platonic orgy of ass-sniffing, ball-chasing, sun-basking, and flea-scratching. Here there are no insecurities, no biting, no fear, no aggression. Everyone is lolling around in the submissive

position. Inside these walls, every day is a vacation in the Caymans, punctuated by occasional public excretion. It is Doggie Utopia. It is Eden. It is the chosen place the rest of us have foolishly forsaken.

When Cesar brings Fluffy here, the angry mean nasty nipping Fluffy, the same thing happens every damn time. Fluffy, who was just seen ripping the larynx out of a mailman, proceeds slowly, precariously, full of worry and fright . . . and then, within *seconds,* Fluffy is lying around and playing with the rest of the dogs. Fluffy is not hiding and then pouncing. Fluffy is walking with perfect, Westminster-quality posture, sharing the tennis ball with other dogs, tanning, licking everything in sight. It is wordless and beautiful. What happened? What did Cesar put in the water over there? How are they communicating? How is this happening?

Only Cesar and Daddy know. They hold the keys to the Puppy Elysian Fields. It is their biodome. All are safe.

• • •

Eventually, Sid killed Nancy, because that was the logical answer, really, to every question they'd been asking each other. Thank God Jill's Sid didn't kill her. But one Saturday morning I got a call saying it was over, that he'd just come home after dinner one night and told her he was tired, that he couldn't do it anymore. Within ten hours my parents were on a plane to Oakland; within sixteen Jill was in the backseat of her car as my dad, Daddy, drove her back to Mattoon. She had no friends there. She had no job. She had no money. She had no place else to go. While Jill was being a spitfire and fighting and growling and loving, she was setting up a family life in a more intricate,

and more devoted, way than I ever had. I'd always had an escape route. She never did. When it all blew up, there was nothing left. She had created order out of chaos, only to learn that it all turned into chaos anyway. It always does.

She's at home now, as I type this—resting, crying, figuring out what's next. I am still thousands of miles away. I am playing it safe. I have played it safe. I have order. I have life in a calm, submissive position.

I want to be there for them, for her, all the time. I want to give my parents, my fiancée, any family of my own a safe cocoon, a biodome, a place where they're defended from those who would do them harm, including themselves. I want to discipline them not because they are out of line but because the world's discipline will be so much harder. I want there to be order. I want to live in one place, with my family, and be able to control them so that they will learn to control themselves. I want my family to be a haven from it all, a place where everyone is of one mind, where everyone trusts one another and knows when to submit their own petty desires for the better good of the paternal structure. I want a place that's safe. Where we are one.

I want to be the Dog Whisperer.

But I do not know how to do any of this. When I have a family of my own, I know that every mistake, every downfall, every skinned knee, every D in school, every unwanted pregnancy, every misguided tattoo will all be my personal failures, symptoms of my inability to protect my children, my puppies, my *precious*, from the vagaries and indecencies of the outside world.

The perfect home cannot be found out there. I hope Jill is

okay. But I don't know. The world has punished her for her brashness, for her willingness to take risks and tempt the fates, and it makes me want to destroy everything I survey. Or just hide from it. Keep it away and safe.

I can keep them safe. I tell myself: If I dare, if I trust myself, if I can overcome how evil and venal the outside planet is, they will be happy and well and warm, and I can keep Jill that way, and my fiancée, and everyone. I can do it right. I want the Dog Psychology Center. I can be Cesar. I can be Daddy.

My hand is the mouth. My fingers are the teeth.

7

HONEST, HONEY, I'M NOT GAY, I JUST LIKE WATCHING HALF-NAKED BUFF GUYS WITH FULL-BODY INK

Jerry Stahl

NO DOUBT KYLE DIDN'T REALIZE, when he was given fifteen to life for murdering his brother, that the American viewing public had a very different future in mind for him than the Department of Corrections. Thanks to the good people at MSNBC—and their wildly popular, endlessly rerun prison documentary series, *Lockup*—his ultimate fate was far more extreme than mere "inmate." Kyle was sentenced to become . . . *entertainment*.

Lockup, for those with lives and/or fulfilling late Friday and Saturday plans, represents the first wave in a torrent of prison porn that permeates the nation every weekend. (The National Geographic Channel—rebranded as the NGC—now also includes its own prison series; there's something poignant in how they've morphed from the magazine you'd scan for pygmy tit to another network of shirtless convicts. But that's a whole other issue.)

Every Friday, after MSNBC's normal viewers call it a night, the top executives hand over the keys to the Penitentiary Fetishists and drive home to Connecticut, leaving a nation of Vicarious Incarceration Junkies and Solitary Confinement Ecstatics to feast their eyes and gorge their souls—until Monday—on the heinous drama of doomed, muscle-bound men leading lives of nonstop physical menace. Lives that, in their very fluorescent-lit naked danger and sadness, may be the only spectacle left with the power to take the viewer away from his own quotidian agonies.

At one point, though it's mathematically impossible, I believe that the network was actually running six hundred hours of prison documentary every weekend. Until "reality" news in the form of *Morning Joe* returned on Monday and bumped the reality documentary show off the air.

Turn up the sound! When the big man movie guy starts off every show, you can close your eyes and imagine the $5,000-an-hour voiceover pro with a bad toupee leaving a coffee ring on the studio promo copy.

Among the nation's toughest is California State Prison, Corcoran. It's severely overcrowded and plagued by racial tension. We spent months inside this institution with a notoriously violent past, where officers try to maintain order. In this episode, we focus on inmate interaction, which, in prison, is volatile at best—whether it's with officers, disputes with other races or gangs, or even a prison romance. In Corcoran, it's not a question of if there will be violence, but when.

And I say: *Yes!*

The chyron says *Lockup: Corcoran—Extended Stay—Road to Redemption* . . .

If Bruce Willis strode out and smirked, no one would blink. But the inmate they get to tell a story is even more guileless.

Lockup operates on the principle that crime may not pay—but punishment can attract a variety of attractive sponsors, from anti-snore devices to Benadryl. The chocolaty center of every episode are the personal narratives, all reliably worse than your own.

Such is the beauty of the prison doc. Regardless of the adjectives that may currently adhere to *your* life, they're generally better than the ones describing the existence of a convict. So what if you find yourself staring at convicted felons at four in the morning with tears in your eyes and a bowl of cereal balanced on your leg? At least it's your television—or it's not, at any rate, owned and operated by the city, state, or federal Department of Corrections.

LISTEN! It's our friend Kyle again. Shaved-headed, goateed, bright-eyed Kyle. He's talking about people who have committed sex crimes, child molesters, gang dropouts, and people like him that have testified. *My path to prison started when I got caught selling drugs in Little Rock, Arkansas.*

Except for the inked-on CUT HERE around his throat, he looks like a cleaner-cut Woody Harrelson.

I live on SNY 3 C facility. It's a sensitive-needs yard for inmates that cannot program around the general-pop inmates.

Here comes a winning smile that might just as easily grace a baseball card. Perhaps Kyle was driven to crime by having a difficult-to-pronounce last name, one that I'm not even going to try to spell out here. I had a gym teacher who, for six straight

years, called me "Gerlad Stale." I'd be lying if I didn't admit I had fantasies about doing things to his face with the Ping-Pong paddle he always carried in his back pocket for swat purposes.

• • •

KYLE, the chyron reads, IS SERVING 25 YEARS TO LIFE FOR SECOND DEGREE MURDER.

Turns out Kyle's family set up him up. Only he didn't know it till way later. His father asked him how much it would cost "to get a dog run over."

My parents and my sister wanted to get her husband killed for supposedly molesting their daughter. My parents were phoning me constantly. So at that time, I decided, "Hey, this is family. I gotta do this." So I asked him, "Dad, hey, tell me exact time, the exact place." They say Tuesday, two-fifteen, he would go to pre-school, pick up his kids . . .

So I went to McDonald's, grabbed something to eat, went to some abandoned horse trail, put on my disguise, and went and waited. I waited for what seemed like forever. He parked in the parking lot, twenty feet from the day care center. I remember the blinds were drawn. That's why my relatives said it would be a good time. Because kids would be sleeping. Blinds would be drawn. Nobody would see me. I tapped him a few times on his window. As soon as he looked, I knew it was him. I didn't think. I just started shooting. I didn't count bullets. I didn't know how many I fired until I read the police reports.

Now here I am. As much as I would like to say that I killed for a righteous and solid reason in people's eyes, the truth is, I believe I was mistaken. It was a bitter custody dispute. And

*one of the ladies manipulated us all. And the truth is, I may
have been mistaken. I may have been played. I may have
done all this for no reason at all.*

*You testify, then you're a rat. I ended up telling them the
whole story. Implicated my relatives. So I'm the lowest of
inmates. Because I decided to tell the truth and implicate
other people. Every day I think about this, that this may be
my home. I don't deserve to get out. . . .*

A sense of hopelessness kind of sneaks up on Kyle's perky
delivery at the end. But still, as bad as things are . . . he's on TV.
As Gore Vidal once famously said, you should never pass up a
chance to have sex or appear on TV. Competing for face time
with charismatic baby-killers, three-time losers, and born-
again, blacked-out wife-throttlers, Kyle made the cut. How
bad, really, could life be?

• • •

Theories about why the cable public loves inmate docs range from
the paternal to the patriotic to the homoerotic. America, God
bless her, jails more of her citizens than any other country on the
planet. Roughly one in a hundred Americans, at any given time,
are guests of our country's penal system. Which may explain
the popularity of prison documentaries: It's the cheapest way
for folks to see their families. *Oh look, there's Uncle Sweets!*

On the other hand, the allure, if I had to guess, is not unlike
what makes MSNBC's sister broadcast, *Predator Raw*, such a
runaway success. With one difference: The pedophiles on *Pred*
constitute that rare slice of society that is unquestionably more
morally reprehensible than anyone else on your Christmas

card list. Plain old convicts, by contrast, occupy that niche of mythic outsider guys who have been represented on-screen by everyone from Paul Newman to the cast of *Oz*.

Prison, as made palpable by MSNBC, is like life but scarier. Even if you can feel superior to triple-homicide Ace from East Nebraska, there's no denying that his skills make life in super-max a lot easier for him to deal with than it would be for you. The amount of incipient ass-kicking and shiv-sticking on any given episode of *Lockup* is staggering. As ratings slump and some other thrill comes along, a new title is rumored to be in the works: *Shanking with the Stars!*

But it's not the physical violence that's so frightening. Or not just.

After my first 479 hours of viewing, I finally nailed down the source of a deeper chill. I was watching Associate Warden Lopez, a full-faced, mustached man, as he hosted the Internal Classifications Committee in a confab with an elderly African prisoner. The prisoner, in a yellow jump suit, slumped further south with every word. *"I am here to review the asset placement, to determine if their housing is appropriate, and to insure that due process has been available to them."*

Inmate Ed Dwayne Smith and his cellie have been charged with prison murder. But to hear Ed Dwayne plead his case, he might be here for having filled out a 1040 in pencil rather than pen. "I've been trying for a month to get my RBRT heard!"

"Well," says the associate warden, "did you not postpone, pending the GA?"

"Sir?"

Now it's time for another full-faced Anglo in a CO uniform to chime in. "Did you forward your request? When you return

back to your cell, write a quick note saying that you want this 115 heard, immediately. And this way we can devote your postponement."

Poor Ed Dwayne is getting the okeydoke from the COs. But that's not the worst of it. Maybe there's a deeper terror here that America relates to—the spectacle of a heinous bureaucracy on parade. On some level, for these guys, being in prison is like living in the DMV—being forced to line up and fill out forms and ignored to your face by people who don't care if you've been waiting in the wrong line for thirteen years.

What does it say that America gleans entertainment from men whose entire lives are a struggle to maintain dignity, sanity, self-respect, and (in some cases) anal virginity while locked up by the state? Nothing, I suppose, but that they're documenting more interesting times. Most of the shows airing today, after all, are reruns: shot during the Bush era, a clearly more naïve time.

Perhaps, in these times, we should be gearing up for deeper amusements. We can at least pride ourselves on the fact that we know where our prisoners are—no more black sites, so to speak. But my guess is that producers are going to need to go the extra mile. Until camera crews shoot full-on executions—what are we, barbarians?—then how about full-time cell-cams on the first batch of neocon torture-paths to go down for taking bites out of the constitution? Make *Alberto Gonzales: The Ad Seg Years!* a pay-per-view event, and I'll be there with the guacamole.

Lest we in the United States feel like we invented penal entertainment, in this regard—as in so many others—we take a cultural backseat to the French. For a time, during the French

Revolution, executions by Madame Razor were a massively popular entertainment. Enterprising vendors hawked programs listing the names of the Soon to Be Dead. Spectators came to blows over the best seats. Those legendary ladies known as *tricoteuses* sat up front knitting, day in and day out, functioning as cheerleaders of a kind. Parents would bring their children. And why not?

One visit to the section of the MSNBC Web site devoted to *Lockup*, I'm happy to say, and it's clear the producers have preserved the family-friendly nature of the enterprise: "Hi, everyone, My name is Elise Warner. Rasha Drachkovitch, of 44 Blue Productions, and I are the executive producers of MSNBC's *Lockup*. I hope you will find Newsvine to be a great source of information about the shows . . . and an even better place to meet other *Lockup* fans."

That's right. If you don't have a family of your own, you can hook up with other *Lockup* aficionados. Talk about a match made in heaven! Am I the only one sniffing romance? Here's Elise opening her heart to a coupled-up fan who just wanted to share the magic, on April 7 of last year: "Hi Scott! It's so great to hear how much you and your girlfriend love the show . . ."

I'm not usually such a puppies-and-buttercups kind of guy, but, damn it, when I think of the possibilities of a bond based on a shared love of watching grown men in chains, condemned to a lifetime behind bars—well, where are the words?

If I were one of those big-city mayors cutting tax deals and land-use exceptions to lure corporate-based ballparks into their districts, I'd say you're backing the wrong pony, Your Honors. Why not hitch your wagon to the one dependable growth industry this nation has left—incarceration? Forget the

Mets or the Raiders, how about putting those corporate boxes in a penitentiary—stepping things up to the next generation of incarcer-tainment, Prisons with Stadium Seating?

Sure, it's exciting to watch outlaws in Pelican Bay and San Quentin play hide the trazor with COs, but, as the professional sports fans will tell you, there's nothing like seeing something under the lights, with the roar of the crowd—in this case, the peculiar must generated by the stale socks-and-flatulence of a few thousand overcrowded inmates. Sooner or later, some enterprising governor—my money's on Schwarzenegger—looking for ways to tug his ever-diminishing budget back from the brink, will hit on the idea of combining Folsom with Dodger Stadium.

Which is a whole new reality.

BECOMING A LADY

Amelie Gillette

WATCHING LADETTE TO LADY ON THE SUNDANCE CHANNEL one lazy Saturday afternoon, I was instantly reminded of Princess Diana's death—which probably isn't the association the producers were hoping for. Still, it happens.

I was at an after-party for a rave in New Orleans when I found out that Princess Diana had died. I'm not bragging, obviously. "After-party" and "rave" are words that haven't been used boastfully since about 1997, and even then it was mostly among teenagers in parts of the country that were the absolute last to get the raves-are-thumping-neon-nightmares memo: high school kids in pacifier necklaces and bright yellow SUGAR DADDY T-shirts—which is exactly who I was when a skinny blond kid named Jason, who looked like he was being swallowed from the feet up by denim, ambled across the dewy green

grass of the lakefront, flopped down on the blanket beneath the tree where my friends and I were wasting our lives, and exhaled, "Y'all, did you hear? Princess Diana is dead."

This being an after-party for a rave, none of us moved for about the next twenty minutes or so, at least until the sky stopped spinning and the ringing in our ears went down to a mildly pleasant hum. Finally, someone spoke. "I know how to curtsy to Princess Diana." For me, this sentence was especially surprising to hear, mostly because I was the one saying it. Still, I did know how to curtsy before royalty: hands at your sides to keep your skirt full but also to steady yourself, the right foot tracing a slight semicircle on the floor before coming in behind the left foot as your knees bend in almost a crouch, your head bowed gracefully. (Only actual royalty gets the head bow—an important distinction in New Orleans, where Mardi Gras kings and queens walk among the plebes.) Within a few minutes, I was on my feet, fluffing out my oversized jeans to give the impression of a skirt, and practicing the curtsy that had been ingrained in me many years ago in Mrs. Abadie's manners class. "Damn. That's some debutante shit," my friend Aristede, who was dressed head to toe in vintage polyester, observed. Elena, my best friend since third grade, who was wearing her hair very short and very platinum blond with very many dyed leopard spots, laughed. "Your mom would be so proud."

From what I understand, entry into the demimonde of New Orleans debutantes amounts to an accident of birth. If your mother was a debutante, you can be one too, even if you're battling some kind of terrible deformity like a cleft palate, an unfortunate unibrow, or a Yankee father. I'm sure there are other

ways to get in—joining the appropriate Mardi Gras organiza-
tions, making the right friends or other social climbing skills
that are usually the province of Edith Wharton novels, an
elaborate scheme of sizable donations and secret payoffs to
certain key figures in the murky deb underworld—but I'm not
certain what they are. All I know is that my mother was a deb,
as evidenced by the large photograph of her, resplendent in her
long white kid leather gloves and a cream-colored satin gown,
hanging in my parents' dining room. And just as I inherited
her impressive height and green eyes, I had been passed along
the opportunity to hang photographs of myself as an intimi-
dating debutante (probably for the express purpose of taunting
my reluctant daughter) in my own house someday.

I didn't ask for this, and growing up, I certainly didn't want
it. Every Tuesday afternoon when my school's resident man-
ners and etiquette teacher, Mrs. Abadie—a prim, white-haired
woman whose voice was so round and jolly, she would have
been perfect to play a cartoon chicken in a Disney film—came
around to instruct my third- and then fourth-grade class, I
would slouch in the back of the room, hoping to go unseen. But
as it turns out, slouching in a manners class only makes you
more visible. "Posture, posture, posture!" Mrs. Abadie clucked
at me constantly, as she was going over the proper way to sit
(ankle over ankle, never knee over knee), or to curtsy, or to hold
a fork. I slouched—because even at that age I was relatively tall
and therefore relatively awkward, but also because I usually
had an open Lois Duncan book hidden in my desk, and slump-
ing down in my chair was the only way I could read it virtually
undetected, staving off what I thought would be an inevitable

death from manners-class-induced boredom. Once, Mrs. Abadie made me practice my curtsy in front of the class, and my cheeks flushed with embarrassment as she corrected the curve in my shoulders. "Back straight and proud, Miss Gillette," she said. "When you slouch, you're not a young lady, you're a mouse. Now try it again." I wanted desperately to get the curtsy right just so I could go sit back at my desk and find out what was going to happen to the babysitter in *The Third Eye*. By Christmas, I had learned how to hide my book in a sweater on my lap—as well as, reluctantly, how to sit up straight and proud.

While my older sister happily pursued the debutante path when she turned twenty (the usual age for coming out, in the deb sense, in New Orleans)—relishing all the many trips to the dressmaker, giddily penciling in the dates of various balls, holding actual lengthy conversations about tulle—I happily scorned it as I made my way toward my twentieth birthday. The whole thing just felt, you know, stupid. I had gone to an arts high school. I was going to be a writer. I was living in New York and going to NYU. Why would I want to traipse home to New Orleans almost every other weekend of my junior year to dress up like an (elegant) marshmallow, drink champagne with girls I never liked, and curtsy before a crowd of my parents' friends? I had a crappy college radio show to produce and several Dallas BBQ locations to visit ironically with my friends. Just the idea of doing the debutante thing felt stifling—as if the merry widow I would almost certainly have to wear would be crushing my brain as well as my ribs.

"I just don't want you to look back and regret not doing it," my mom said, her voice heavy with disappointment, when I

told her that despite all the manners lessons and private schooling up until my arts school defection, I wasn't going to ever own long, white, kid leather gloves. "Don't worry," I laughed. "I won't."

By the end of a daylong *Ladette to Lady* marathon on the Sundance Channel a few months ago, however, I realized I had spoken too soon. As I watched the three remaining ladettes—that's British for both "tomboys" and/or "boozy tarts"—dramatically descend a winding staircase, dressed in impressive ball gowns that they had made themselves in dressmaking class, hair perfectly coiffed, backs perfectly straight, and attempt to pass themselves off as actual debutantes to a coterie of scathingly judgmental lords and ladies, I felt the slightest twinge of envy, if not regret. When Clara, an awkward, shy tomboy, and the girl I related to the most (we're both tall) glided down the staircase, stunning in her pink gown and improbable, gravity-defying chignon, I found myself thinking something that in all my years of watching reality television I have never thought. *I could win this show.* More specifically, *I could wipe the floor with Clara. They want debutante? I'll show them debutante.*

There are probably chefs who watch *Top Chef* and think, "I could make a much better appetizer with Quaker Oats and seafood." And fashion designers who watch *Project Runway* and think, "They want innovation? I'll show them innovation. Hand me that aluminum foil." And hairstylists who watch *Shear Genius* and think, "*This* is my profession? Jesus. What am I doing with my life?"

Ladette to Lady, however, is in a different reality competition category. Like VH1's *From G's to Gents* or *Charm School*

or (everyone's favorite) *Tool Academy*, it's a reeducation reality competition. The show takes ten crude, pint-gulping "hard-core ladettes" and ships them off to Eggleston Hall, an austere, fancy-pants finishing school where the curriculum (cookery, flower arranging, dressmaking, deportment, elocution) hasn't changed since about 1950. All the while, their actions are coolly commented upon by an unseen narrator, who can sometimes fool you into believing you're watching a nature documentary rather than a reality show. When Louise, a very pretty contestant from season two is shown downing glass after glass of wine following a dinner party, the narrator intones, "Some girls rose to the occasion—while others let themselves down."

The stated goal of *Ladette to Lady* is to transform the girls into "ladies," but what that translates to is "self-confident, slightly more polite, definitely less drunk young women." In the first season, the girls who hadn't been "asked to leave" (that's British for "eliminated") got to show off what they'd learned in a sort of public final exam: it was part fashion show, part speech, part floral arranging and cooking demonstration. But the second season's finale was far more interesting, at least to me. In addition to each giving a speech about their experience and final exams in floristry and cooking, the final three girls had to pass themselves off as debutantes at a ball, *My Fair Lady*-style. All the girls succeeded in looking the part, but sounding like true British debs was another thing altogether. Each of them was given away by her accent. Where is Henry Higgins when you need him?

My accent was the handicap in my fantasy *Ladette to Lady* ball. After a few weeks of cooking classes, I could definitely

whip up something edible. I'm sure if I paid attention to Jill Harbord, the stern floristry teacher at Eggleston Hall, I could sufficiently pretend that flower arranging is an actual skill—as opposed to, you know, putting flowers together in a way that doesn't evoke sweet-smelling chaos. There's no question that I could carry myself like a debutante—after all, I was literally born to do it. But my American accent would undoubtedly be a huge obstacle in passing myself off at a ball as a British deb- utante. I pictured one of the crusty, be-sashed lords greeting me at the bottom of the staircase and trying to disguise his disgust as soon as I opened my mouth. Later on, he'd turn to the camera and say, "She's a lovely girl. Not a debutante, but lovely. Unfortunately her accent was so American it made my eyes smart."

So you can imagine my excitement when I heard that an American version of *Ladette to Lady* called *The Girls of Hedsor Hall* was in the works. I actually considered develop- ing alcoholism, a love of self-tanner, and a penchant for yell- ing "Woooooo!!!" at the top of my lungs at any and all occasions in order to fulfill the "ladette" requirements. Then, once accepted, I could gradually slough off all of my crude pseudo-habits, until I'd be the most improved student, and the belle of the ball I never, in my real life, wanted to attend. But though *The Girls of Hedsor Hall* shares the same concept and some of the same instructors as *Ladette to Lady*, it is a very different show. For one thing, it's produced by Donald Trump, that world-class connoisseur of reality-show cheese. For another, it airs on MTV and unfortunately adheres to that network's tiresome reality-show blueprint: melodramatic

elimination ceremonies occur with regularity; petty sniping about the other contestants in interviews is wholeheartedly encouraged; the production values are so low, it looks like it was shot in a fiberglass approximation of a mansion; and the ultimate goal of the show isn't self-improvement, but a cash prize of $100,000.

In the first episode of *The Girls of Hedsor Hall*, each of the extension-clad, over-tanned party girls is dramatically presented with a strand of pearls. The necklace is a symbol, Jill Harboard reminds them, of their aspiring ladydom, and as such, it must be relinquished if they are asked to leave Hedsor Hall. The girls, however, aren't so impressed by the reality-show trope being fastened around their necks. "I don't really care about the pearls. It's bullshit," one astute, though orange, girl named Brianna tells the cameras. "It's about our attitude, not about some freaking pearls around our necks." Over the course of the next few episodes, Brianna is proven right. It isn't just about some freaking pearls around their necks; it's also about stomaching ox tongue, removing the entrails of a pheasant, and learning falconry (yes, falconry) in the name of self-improvement. Only after all that does it become about a change in attitude, a new sense of self-confidence.

Watching Brianna rip the feathers from a pheasant carcass, I understood that I had already been where she was—not literally, as I don't use up at least 78 percent of the world's supply of self-tanner, I don't have my own adult Web site, and I've never touched a dead game bird. But my own reeducation happened a long time ago, in manners classes and Mardi Gras balls and curtsy drills. I went into those things a shy, slouchy,

awkward child, and emerged on the other side a woman with excellent posture who was self-confident enough to opt out of further deb-ifcation, and poised enough to execute a perfect curtsy at seven a.m. in ridiculous raver wear. No debutante ball needed.

SHELLY

Ben Mandelker

WE ARRIVED AT CBS AT THREE O'CLOCK wearing black. Or was it blue? Either way, the tickets told us to come dressed "business casual," and if I do say so myself, I was looking cool. Cool enough, that is, for me to potentially end up on camera, take a screen grab of that, and then post it on my blog and Facebook profile.

My friends and I were at a live taping for *Big Brother*, the CBS reality show that places a bunch of strangers in a house filled with cameras and lets them go at it for an entire summer. While I don't know who would submit themselves to such torture, I guess when it comes to money and fame, people will do just about anything.

And thank God for that, because, for the entire time *Big Brother* has been on the air, I've been infatuated with it. A lot

of my more cerebral friends—the PhDs, the investment bankers, my mom—are completely perplexed as to how I could become so wrapped up in a lowly reality show. I tell them it's because I'm drawn to *Big Brother*'s unpredictable nature. It's a fascinating social experiment, I say—kind of like watching a human game of chess. *Big Brother* is one reality show that puts scheming and strategy above all else. These people are stuck in a house with nothing to do but plot the demise of their competitors. With all the allying and backstabbing, it's akin to watching a pack of hyenas battle it out over some dead, bloody carcass—only the hyenas have abs and fake boobs, and the carcass is worth half a million dollars.

Yes, that's what I tell people, mostly because it makes me sound vaguely academic; it also happens to be true. But the *real* reason I tune in is for the fighting. And the meltdowns. And the hookups. The show is a pressure cooker for the contestants, and watching people's mental states slowly deteriorate is part of what makes this show so grippingly fantastic. Plus, unlike other major reality franchises, *Big Brother* airs three nights a week—and that's on network TV alone. Subscribers to Showtime get the seductively named *Big Brother: After Dark*, which airs three hours of live footage from within the house every single night of the week for three months straight. Throw in live Internet feeds that run 24/7, and viewers have a near constant supply of bickering, screwing, and gossip. You barely have an opportunity to get away from it.

After spending nearly all of my summers of the new millennium obsessing over *Big Brother,* I figured I'd earned the right to show up for a taping or two (or six, as it were) now that CBS was allowing a live studio audience during the "eviction" epi-

sodes. Of course, this meant having to mix and mingle with a variety of strange people from all walks of life, which was tremendously disconcerting for me. Living in Los Angeles—an epicenter of pop culture, style, and celebrity mania—it's all about who you know, which stars you can name drop, and what crowds you can align yourself with, and loitering around with Middle America was certainly *not* boosting my precious cool cred, thank you very much. Nevertheless, I attempted to curb my urbane contempt. As I arrived at CBS for my fourth taping, however, I discovered that my threshold for egregious behavior was much lower than I had ever expected.

The bane of my existence that day was one loud audience member, whom I called Shelly. I didn't actually know her real name, but she just seemed like a Shelly (apologies in advance to other Shellys of the world). She was, to put it mildly, awful. It wasn't the first time I'd seen her. No, I'd had the privilege of sitting behind Shelly at my second taping, which meant I had already been privy to her awfulness.

Shelly's major problem was that she thought she was the star of *Big Brother*—or the star of, well, anything. She was one of those tragic attention-seekers who seemed to feel that if she were just wacky enough, maybe a casting director would pluck her from the audience and place her on TV. As a result, she spent much of that first taping being loud and cracking dumb jokes, which would have been fine if she'd been (a.) funny, (b.) interesting, or (c.) a few decibels quieter. Instead, her jokes were lame, her comments inane, and her voice booming. Every time she opened her mouth, all the people in my section shared disbelieving looks, as if to say, "Can one person be *this awful*?" Part of me hoped some sort of mob rule would take over the set, sending

Shelly to the curb outside in a flurry of screams just shy of a Shirley Jackson stoning. Alas, the crowd never mobbed, so I had to contend with what I had: my furious eyes, which, tragically, went primarily unnoticed because I was sitting behind her.

And things went from bad to worse. In the middle of the live show, Shelly let out a very loud, *very* audible *"Whoo hooo!"* despite the fact that we'd been told explicitly, several times, to be quiet while the cameras were on.

Luckily, a stage manager reprimanded Shelly during the next commercial break—which, while wonderful, wasn't nearly satisfying enough for me to be able to forgive Shelly for her complete lack of self-awareness. I comforted myself with the knowledge that after the show, I'd never have to see her again.

But now here she was again. The demon with the white hair and cat-eye glasses was back. And worse than ever. In a mockery of the mere concept of "business casual," Shelly was decked out in a lime-green tank top and gaudy, hot-pink floral print capri pants, as if she were not an audience member but an old couch from Boca Raton.

Within moments of taking her place in line outside the soundstage, Shelly folded a piece of paper into an airplane and began throwing it around. And she was even awful at *that*. She didn't attempt to get the damn thing airborne, just flicked her arm in a sloppy, downward motion that sent the stupid plane careening into the ground each time. The problem, however, wasn't her lack of comprehension of basic physics or paper airplane throwing (gentle thrust *upward*!). It was that she was so obviously pining for attention. Why couldn't she just sit down like the rest of us?

Thankfully, the CBS pages put us out of our misery—not, sadly, by strapping a muzzle onto Shelly's face, but by ushering us into the studio. It was the same studio where all the *Big Brother* contestants had stood on the season premiere, ready to begin their quest for $500,000, now filled with bleachers for us to sit on. Unfortunately, we couldn't choose our own seats, and I felt a twinge of apprehension as I feared I might be seated Shelly-adjacent again. Joyfully, though, this time I was placed on the opposite side of the audience. With a good thirty or forty feet between us, I figured, I would finally have the necessary Shelly buffer I so desperately needed.

Oh, how naïve I was.

Once we were in our seats, a producer stepped onto the stage to warm up the crowd. He invited various people down to the stage to play some *Big Brother* trivia for T-shirts—but of course I'd been there, done that. (At taping number two, I'd accurately identified Jerry as the houseguest who had thought a recent earthquake was just a truck backing into the *Big Brother* house. *Booyah:* free shirt.) Anyway, to my delight, Shelly was not chosen to participate in the trivia excitement. But that didn't stop her from blurting out answers and guffaws from her seat in the audience.

As it turns out, however, Shelly was just warming up. Because about fifteen minutes before the live show, the trivia came to an end, and the affable stage manager, Eric, stepped out in front of us to lay down the ground rules for the audience. It was mostly commonsense stuff: Don't slouch, don't frown, don't look for yourself on the monitors overhead. The whole point was that, as audience members, we weren't supposed to

detract from the host, Julie Chen, or any of the action happening onstage.

When you're wearing a tank top the color of split pea soup and pants that look like a discarded tablecloth, however, blending into the background clearly isn't a high priority. Sure enough, as the stage manager took questions from the audience, Shelly stepped into overdrive:

"You rock, Eric!"

"Can we give a standing ovation to *you*?"

"So I take it I shouldn't scream? Hahahah."

It was like she was trying to show all of us what close friends she and Eric were—despite the fact that they clearly didn't know each other. Eric obliged Shelly with lighthearted responses, but it was evident that he had more pressing matters to attend to—like his job, for instance.

Yet Shelly couldn't be contained. By the time Eric had finally broken free of her banter vortex, she was ready to move onto her next target: Julie Chen. Julie, you see, had arrived on the set ready to rehearse, and, after waving to the adoring crowd and unleashing that trademark smile of hers, immediately begun prepping for the show.

But Shelly didn't let the fact that Julie was clearly occupied get in her way. With only a few minutes left before going live, Shelly turned to Eric. "Could I ask Julie a question?" *Whaaa?* She wanted to speak *directly* to Julie Chen? Only a fool would request such things. And sadly, Shelly was our fool. Our awful, awful fool.

Eric would surely have turned down Shelly's request, but as luck would have it, Julie happened to be standing within earshot, and it would have been rude for Eric to refuse a request

that Julie herself had clearly heard. So Eric stammered a bit and looked over at Julie, who looked back at him as if to say "Seriously?"

Eric then asked in a hushed, confused way, "I—I don't know . . . Um, Julie, do you want to—" Julie put on her game face and smiled to the audience, saying she'd be happy to answer a question.

"What's your favorite season of the show?" Shelly asked, a goofy smile spreading across her bloated face. *That* was her question? Really?

Julie paused for a moment, then rattled off a brief answer; it wasn't particularly cold, but it probably didn't leave anyone thinking she was dying to continue this discourse. Less than half a second after she finished speaking, though, the floodgates opened up. Clearly inspired by Shelly's boldness, practically every member of the audience started assaulting her with questions.

Julie looked a bit surprised. At previous tapings, she'd never had to deal with such mania. The audience had always left her alone, in much the same way that spectators don't ask Andy Roddick "What's your favorite cheese?" right before he serves up a ball. Most people recognize the invisible line between audience and entertainer, and we cross it only when we've been specifically invited to do so. But Shelly seemed blissfully unaware of this notion. Audience and entertainer were all one tangled mess—a cohesive whole that justified a lack of deference for Julie and Eric or even herself.

Thanks to Shelly, nearly everyone in the audience had their hands in the air, like kindergartners begging to go to the bathroom. The idiotic questions abounded: "Is it true that Nick and Jen are dating?" "Are Evel Dick and Daniele on good terms

now?" "Are Eric and Jessica still together?" Jesus, had these people never heard of Google?

Julie answered all the questions in stride—even the most idiotic ones—but it was clear that her focus was on the show she was about to host. It was pure torture for me, and not just because etiquette and good manners were being so thoughtlessly thrown out the window. The truth is, I'd waited years to talk to Julie Chen. But not like this, as part of some unhinged feeding frenzy. Ever since I'd started watching *Big Brother*, I'd been fascinated by her robotic delivery. I wrote about it on my blog, often referring to her as "The Chenbot," and the more I discussed her, the more enamored I became. How could I have disdain for a woman who entertained me so thoroughly? At one point, I went so far as to create a video compilation of her saying the phrase "But first," an utterance she delivered multiple times an episode, often in the exact same pitch and tone. Through the magic of the Internet, the video caught on, and suddenly *Entertainment Weekly* was declaring "But First" Julie's official catch phrase. Next thing I knew, people were showing up at *The Early Show* (her main gig) wearing T-shirts that said CHENBOT and BUT FIRST. Critics who once assailed Julie for her wooden delivery now saw the campy fun of it all. Even she seemed cool with it, and for the first time, she began showing more signs of personality and humor.

As Julie had fun with her new image, my friends urged me to find some way to get on the *Early Show* so I could meet Julie myself. Surely she'd want to meet the guy who'd made "But First" a catchphrase. It would be a riot! Everyone would love it!

These were my more open-minded friends, of course—the ones who, during the summer months when *Big Brother* airs,

gather around the TV with me, watching live feeds of the contestants for upward of two or three hours at a time. We don't mind sitting in the living room, ogling other people as they get drunk or fight or make out. It's such a pleasant alternative to actually going out and meeting real people. Los Angeles can be brutal on that front, and the last thing I want to do is stand in some line for some club for two hours only to be told I've got too many dudes with me to get in anyway. Meanwhile, the douche bag in the dumb fedora can just waltz right in because he's taking acting classes with Paloma, the new waitress on Wednesdays who seems all sweet and friendly but talks only to guys who've booked a national commercial and/or have a three-picture deal at DreamWorks.

Sure, let Fedora in. Meanwhile, someone like me, who's actually smart and not dressed like a total idiot, has to stand behind a metal gate and twiddle his thumbs with little else to do but ponder the reasons he's not good enough to get in. Am I too hunched over? I've been trying to work on my posture. Is it my outfit? Not trendy enough? Maybe I'm not as cool as I thought I was. Now I'm feeling awkward, and it's probably showing all over my face. What should I do with my hands? Do I put them in my pockets? Or do I let them hang by my side? Maybe one in and one out. Or maybe I should cross my arms. No, that makes me look confrontational. But I've already committed, and if I take my hands down now, I'll just look fidgety. I just need to look cool. Oh gosh, I'm going down in flames.

Of course, with practice, I'm sure I could develop a better velvet rope persona. Then I wouldn't look so silly. If I really tried hard enough, perhaps I could get into a club or two, maybe make some connections, and then wind up with a few more

entrées into some more places. But would it really be worth all that cold, callous rejection along the way? Do I really need to submit myself to such harsh judgment all the time?

No. I do not. That's why it's easier for me to stay home and spend my nights with the *Big Brother* cast. They won't reject me. When I'm watching them, *I'm* the one passing judgment, and that's the way I like it. These people are in *my* nightclub. They're my social life. They're the ones I engage with.

Oh God, I think. Who am I becoming? A sad person with no life, desperate for attention but too afraid to seek it through normal social avenues?

Am I becoming a Shelly?

Sitting in the audience that day, watching Julie Chen field a thousand dumb questions from the masses, it occurred to me that there was one thing—aside from some fashion know-how—that separated me from the real Shelly: at least I had self-awareness. Shelly was completely oblivious to her behavior and actions. And in some ways, I envied her that. It empowered her to do things I secretly wished I could do—strike up a conversation with Julie Chen, yap away to total strangers, tell a dumb joke and not feel like bursting into tears. She just didn't seem to care what people thought of her, which was—dare I say it—admirable. Yet it also left her looking like an idiot. And I can safely say that I'd rather deprive myself of admiration forever than take a page out of Shelly's book.

But could I hold strong in the face of utter temptation? There I was, facing an opportunity I had sought out for so long: a chance to converse with Julie Chen. All I had to do was raise my hand and ask one simple question. It could be anything. In my mind, I knew what it should've been: "How do you like being

called the Chenbot?" Surely this would lead to polite laughter, which would then be the perfect opportunity for me to drop a mention of my blog and my role in popularizing the terms "Chenbot" and "But first." This, of course, would wow not just Julie, but the audience; then something would click in the brain of the CBS publicist on set, who would think, "Hey, wouldn't this be a great segment for *The Early Show*? Let's have Julie interview the guy who popularized her catchphrase!" Next thing you know, I'd be waking up at four a.m. to chat with Julie live in the morning, and the interview would go so well that she would invite me out to dinner with her and her husband, Les Moonves, who just happens to be the head of CBS. Then maybe, just maybe, he'd take a shine to me and give me a writing project, which I'd knock out of the ballpark . . . and, well, should I start clearing space on my mantel for an Emmy?

All this could be mine, I thought, if I just raised my hand and shouted out Julie's name.

But I couldn't. I just couldn't follow Shelly's lead. How could I live with the thought, as I luxuriated on my piles of money and autograph requests, that my great success had been inspired by the opportunity Shelly had presented me? Shelly couldn't be that amusing little anecdote I'd tell during my Lifetime Achievement Award speech.

I would rather, I decided, toil away for years in merciless anonymity. So I sat there, quietly stewing—angry at Julie for humoring Shelly, angry at Shelly for usurping Julie, and angry at myself for not being able to drop my hang-ups and just shamelessly blurt out a question.

When the live show began, my chance to at last interact with the Chenbot disappeared. Shelly continued her valiant

attempts to monopolize everyone's attention, going so far as to weep when a contestant was eventually kicked out. And I realized that even though I'd just sacrificed something I'd waited years for, it was worth it. Sure, talking to Julie may have brought me eternal satisfaction, but ultimately, I could never be truly happy if it meant having to Shelly myself out.

Eventually, the taping came to an end. Julie receded to her dressing room, the fallen reality star of the day disappeared in a black car, and the rest of us shuffled out into the bright summer sunlight. The soundstage, which had once seemed so full of promise, was now woefully dark and empty. I never saw Shelly again—thankfully—but I do occasionally wonder what she's up to. I'm sure she's in a crowd somewhere, chuckling loudly to herself and throwing paper planes into the ground. As for me, the other night I did the impossible: I talked my way into a club.

10

JOINING THE REAL WORLD

Anna David

YOU'D THINK THAT, more than twenty seasons in, I might get a little bored. You'd imagine that, after all this time, hearing about the seven strangers picked to live in a house and have their lives taped could potentially get old. You'd probably guess that a show with stereotypes so deeply defined that even a person with only the vaguest notion of MTV's existence could name them—or at least somehow come up with the word "Puck"—would have to be old news to me.

And yet I feel nothing but absolute delight over the fact that *The Real World*, for at least part of the year, continues to be televised for a blessed sixty minutes each week.

So what are the stereotypes the show gives us? There's the Gay (ideally flamboyant), the All-American Guy/Homophobe (typically sharing a room with said gay), the Obnoxious Oddball

(who gets ripped to shreds more than anyone else in the confessionals), the Crazy Diva (usually attractive, often a drama instigator), the Player (who may or may not realize that those numbers he's collected are from girls who are more attracted to the notion of being on TV than they are to him), the Prude (with virginity either still intact or recently bestowed upon the Boyfriend She's Definitely Going to Marry), and the Drunk (which is only to say more drunk than everyone else—he or she is most easily identifiable by the jail or rehab stint). Not every cycle features all the roles—where art thou lately, Play-ah?—and the bodies tend to get better with each passing season, but the formula remains consistent: seven (or eight) people who are selected just as much for how badly they'll mix with the others as they are for their aesthetic appeal will fight. And make out. And fight some more.

Clothes and tears will be shed—often in the first episode—ever-available parents and partners will be called up and sobbed to, walls will be punched, and threats will be made. After David (Obnoxious Oddball) pulled a blanket off of Tami (Crazy Diva) in season two (Los Angeles), however, some basic rules were laid down. From what I can discern, they seem to be that all is fair in love, war, and living in a palace complete with a pool table, fish bowl, and hot tub—provided the violence doesn't get physical.

If it does, you're at the mercy of your nemesis—the one you got physical with—who decides if you'll remain in this Nirvana for twentysomethings or be sent back home early. For viewers, these evictions are a sweet but somewhat confusing pleasure: when, in season nineteen (Australia), Parisa (a too-smart-for-her-own-good Obnoxious Oddball) axed Trisha (a

sassy blond Diva who truly seemed to believe that she was "a good Catholic" despite dispensing cruelty the way a springtime daisy does pollen), it became difficult to decide who was more despicable.

Because *The Real World* isn't about finding the person you most relate to—these are funhouse mirror characters, after all, people made to appear so pathetic and embarrassing and drunk and silly that pleasure radiates from your very soul that you are not, in fact, them. There are, of course, exceptions—Pedro Zamora, who died in 1994 from complications from AIDS, is the most notable—but usually it's all about deciding who horrifies you more. Do you side with the bully who believes she can claim a random guy as her own, despite already having a boyfriend, or the alienated one who can't stop pushing people's buttons? Well, God damn it, Sophie had it comparatively easy. (For the record, I went with Parisa, even though her decision to send Trisha home was the ultimate act of pettiness; her ineffectual social skills kind of broke my heart and besides, Trisha managed to make even Puck seem oddly appealing.)

The fact that I feel perfectly comfortable castigating these people I've never met is particularly ironic given the fact that I so desperately wanted to be one of them myself. In the malaise that was my early twenties—back in my hometown of San Francisco after an abysmal postgraduation stint in New York, realizing that *Parenting* magazine was serious about paying me $18,000 a year, depressed beyond belief that college had ended and I was now meant to fend for myself for meals, rent, and entertainment, and horrified to discover that drinking Amstel Light after Amstel Light and smoking a pack of Camel Lights a day was no longer considered cute and cool but both bizarre

and slightly sad—I spent most of my time wondering how life had suddenly become so inexplicably *real*. I was still packing the freshman fifteen I'd acquired (having added a few more to that initial acquisition each passing year of college with nightly pizza-and-beer binges), and was completely without direction, somehow convinced that the world should reward me.

Into this sea of monotony and dread, like *Pride and Prejudice*'s Mr. Darcy to Elizabeth's dreary, proposal-less, marriage-obsessed existence, came Aaron: blond, handsome, and sweet as could be. He was, as my friend noted while we lay out in a San Francisco park, famous. "From *The Real World*," she whispered with reverence. At the time, I was mostly ignorant— I'd been vaguely aware of the first season, when everyone looked more like the types of people you see in an airport or a Las Vegas casino than the sort who'd swarm the treadmills at the West Hollywood Equinox. But I'd missed the second one, in which Aaron had appeared. Still, I understood enough about fame to know that it meant possibilities, options. Fame had nothing to do with taking the bus to work and answering someone else's phone in the hopes of being able to edit articles about Barney the dinosaur and someday, if you were really lucky, make $19,000 a year.

I became friends with Aaron. Not that day in the park—I don't actually remember how we met but I feel certain that it was through a combination of my self-will and some coincidence, and that he was reasonably entertained by me. While he didn't trash the show that had by that point become my complete obsession (thank God for MTV's devotion to reruns), he was wholly uninterested in talking about it. We became friends—going out to bars, playing tennis, watching TV, lying

out in parks, always with lots of other people—and while he was simply interested in having a new pal, I was feverishly, obsessively fetishizing his fame, and more particularly what my proximity to it meant about me.

And then the miracle happened. "Guess what?" Aaron said one day. "I just talked to the *Real World* producers and they're doing a San Francisco version. They're having trouble finding the right people. So I told them, 'I know this girl who would be perfect.'"

My heart raced. The sun shone. Someone Who'd Been Told by the World That He Was Worth Televising had decided to pass the baton on to me. And I hadn't even dropped any hints! He saw that I was worthy of being picked to live in a house and have my life taped and I felt as honored as I would have if someone from the Pulitzer committee had called to say that my piece on the cracked nipples of breastfeeding moms had been declared a winner.

Aaron told me who to contact and explained that, since they were in the final round of casting, I wouldn't have to go to one of the cattle call auditions or send in a video. There was no way, I was certain, that this could all be a coincidence—my meeting Aaron, *The Real World* moving to my hometown, his belief that I was "perfect" for the show, the fact that I was now clutching the phone number of the Person Who Could Make It All Happen for Me. I was meant to join the real world at last.

Except, of course, the folks at Bunim/Murray Productions didn't think so. Was I too crazy? Not crazy enough? Who knows? I remember the questionnaire I filled out only vaguely: there were queries about my relationship with my parents and friends and what I did for fun, and I recall thinking that my answers

were good—or, more accurately, right. Once they turned the video camera on and I began talking, however, it did occur to me at one point that perhaps I wasn't as riveting a person as I'd always theorized I was.

Soon, however, that taste of potential specialness—of wannabe fame—either lodged its way into my DNA or was awakened from its lifelong dormancy. So when a friend who wrote for *Entertainment Weekly* asked if she could interview me for an article she was writing about people who'd been rejected by *The Real World*, I signed on eagerly. A photographer was dispatched to snap my rebuffed visage, and after the piece came out I started receiving letters from men who'd seen my photo and wanted to meet me. While I couldn't admit it at the time, I was actually far more excited by that attention than I was disturbed by the inherent creepiness of it. And then there was more press! My brother's friend, who wrote for the *San Francisco Examiner*, decided that *Real World* also-rans would make a fine story for her paper, too. With another photo shoot and interview in my pocket, I began to get acclimated to Life as Someone Worth Documenting, oddly convinced that this would all lead to something bigger.

And it did. More letters began arriving at *Parenting* magazine—first from nice-sounding but clearly desperate men, then from the mentally unstable. A guy who identified himself only as Bobby and wrote me long, barely legible letters about how he fantasized about killing his sister, who he was in love with and I happened to resemble, arrived from a jail somewhere in the South—prison stamp intact. And while I was as perturbed by this as anyone would be, I was also unmistakably thrilled by the exciting turn my life had taken. My conversa-

tions were suddenly peppered with references to restraining orders I was considering taking out and numbers I would surely have to get unlisted instead of the usual is-the-office-coffee-drinkable-today chitchat. As a lifelong chronic confessionalist addicted to drama—qualities that, I have to admit, would have made me an ideal *Real World* castmate—I told anyone who would listen about Scary Bobby, the incarcerated lunatic who became obsessed with me after seeing my picture and was obviously going to show up at the *Parenting* magazine office just as soon as he was released.

And then one day, Bobby came to visit. Sort of.

Here's what actually happened: I got a call from the receptionist, who said Bobby was there to see me. *What?* My heart thudded. She insisted it was true. I rose from my cubicle and walked through the Xerox room to the front desk, ready to face my incestuous stalker with the murderous impulses.

There, gathered around the front desk, was everyone I worked with—pointing at me and laughing. Hysterically. The idea, a bespectacled senior editor informed me, had all been his. When he heard me talking about the "fan mail" I'd received, he thought about how "hilarious" it would be to send me letters from fictional insane people. He regaled me, proudly, of the elaborate lengths he'd gone to—having the magazine's art director design the prison stamp, sending the missive to Georgia so that it would have an Atlanta postmark—apparently expecting me to join in the laughter and admire both his creativity and gumption.

But I was incensed. No one likes to walk out and see all her colleagues pointing at her and laughing, but I was horrified beyond reason. Not only was I not special, not worthy of being

watched as I discovered what happened when people stopped being polite and started getting real, but I was pathetic—a girl who was desperate enough for attention that she believed she could accumulate fans for *not* making it on a reality show. This was what my self-obsession and vanity had brought me: humiliation.

My coworkers may well have unconsciously been trying to teach me a lesson about accepting my life the way it was and not pretending it was how I thought it should be—or at least of not blindly believing that all the empty spaces in me could be filled by 24/7 cameras in my face and a possible future appearance on a *Real World/Road Rules* challenge. But I wasn't remotely interested in receiving this information. Years later, when opportunities to appear on reality shows began presenting themselves, I vehemently ran from every single one—as if the more ardently I passed, the further I could distance myself from the twentysomething who thought a stint of televised fighting with strangers would be her only shot at glory.

At the time, I dealt with my mortification the best way I knew how—by doling out a series of dirty looks and promising myself I'd never forgive my co-workers—while wondering what I lacked that Cory, a weepy blonde who was by then being featured on the San Francisco *Real World*, had.

Of course, it turned out for the best. After all, I never had to live with Puck.

11

GAMEBOY

Austin Bunn

THE SUMMER YOU TURN THIRTEEN, an invitation comes to attend "gifted and talented" summer classes at the community college. You paw over the catalog as if this is it—the sign that you're destined for greatness. Your twin brother can't understand why you want to spend a month in a classroom because all he wants to do is play tennis, and he's better than you, so fuck him. You sign up for two classes, How to Win a Nuclear War and Game Theory, and count the days until you go.

See: You are a gamer, but it's not so much a noun as a verb. You game. Not well but often, and with a love and focus that will astound in your life to come. In your bedroom, the *Dungeons & Dragons* die-bags tuck against the shelf of original-series *Choose Your Own Adventures*. You have blasted through the entire series, drawn maps of the story outcomes, even writ-

ten a winsome letter to Bantam on graph paper pitching your own ("BOMB SQUAD!"). Bantam never writes back. Like most Chess Club members, you think winning—and when you say "winning," you mean "pure unadulterated happiness"—is a series of moves executed with a smirk. On the computer in the basement, your masterwork emerges: 'NAM!, a video game about the war with mama-sans and babies on fire that you saw in a Chuck Norris flashback. The hard fact that you are an unexceptional player at everything but War and Old Maid doesn't matter. You smirk all the same. The game itself is the point—the most awesome hours of vanishing into play.

Summer classes start and your mother drops you off every morning with a three-ring binder and calculator. In How to Win a Nuclear War, you learn that, with the right outlay of ICBMs, Guam can rule the world. Also, that 55378008 on the calculator spells BOOBLESS upside down. When you ask your mother if you can fill a trash can with spring water and stash all batteries and flashlights in a "go bag," she is concerned. The coming blast will change her mind. In Game Theory, a professor in sandals and an Izod polo sits cross-legged on the end of the desk. He has weirdly hairy calves, where your own father's are moon-bald. He explains the Prisoner's Dilemma, the Nash Equilibrium, and payoff matrixes. You perch in the front row and make charts you only half understand. Before long, this professor, the master of scenarios and self-interest, becomes a kind of father figure, since your own father doesn't get games— he likes only the Indy 500 and Flight Simulator, in which you can't even shoot things. You wear your own Izod polo shirts in secret allegiance. You learn that everything is economics— every choice a matter of incentives and rewards. You think

that you've never really made any choice, of any consequence, but it's about time. On the drive home, you tell your mom (in barely veiled terms) about your crush on the prof. This is, in a way, the choice. You are thirteen.

She asks, "If he's so smart, why is he teaching at a community college?"

You can't answer. But your zeal is fervent and true. When the grades come in, you receive two A+s . Never again will you feel such a sense of achievement. You write, on beloved graph paper, a winsome letter to the professor, confessing your deep like. He never writes back.

In retrospect, it's predictable that *Survivor* would hook you. It is everything you'd studied that leafy Jersey summer, but playing out like a devilish *Gilligan's Island* or a tropical *And Then There Were None*, the Agatha Christie novel you once adored as a book on tape: Ten murderers get invited to an island off the coast of England and are killed, one by one, by an unseen murderer. Of course no one dies on *Survivor,* but getting voted off the island is a kind of fame-death, a flame-out for millennial culture: proof that your persona doesn't "work."

It seems, too, that that long-ago professor has made his way to Pulau Tiga. While Rudy and Sean and Kelly scrape coconut pulp and stare like zombies at the fire, Richard Hatch is the gamer, a schemer gone to seed, and his video diaries teem with private significance. Hatch is creating *Survivor*'s subtext and you want in. By studying the credit sequence of the show, you discover *Survivor*'s tell: On the day of the marooning Hatch was clean-shaven, but the opening credits clearly show him with an almost-full beard—easily weeks of growth. He would last. (The

producers have since learned to shoot all the character intro montages on the first day.) And while the culture rallies against the easy villain, you find yourself improbably, involuntarily, swept away. You don't even have a thing for bad boys. By this point you're out of the closet and fairly well adjusted, with a favorite bar, a bottle of massage oil, and one or two cool shirts. Yes, you are a little bit of a player, and a player should be above a television fixation. And yet, there he is, on Wednesday nights, bare-ass naked on the shore, and all you can think about is what's behind the pixilated smear of decency.

Look, you always had a thing for Poseidon, for the Norse gods in the monster manual. And Hatch is Poseidon, burly and unashamed. The one that could spear fish. The one with the dolphin tattoo, which suggests both tribal edge and New Age cuddle-fests. You study him closer than you have ever studied anything on television. You con CBS for videotapes of all the episodes and watch them twice. You find the e-mail address for Hatch's consulting business in Rhode Island and gin up an excuse to write him. You know by now how this will end, the zero sum of an unanswered letter. Still, still . . .

A friend of a friend is traveling the world, working as a producer on a new television show, a "*Survivor* killer." A race around the world, with two-person teams. That's enough for you to convince your best friend, Josh, to make an audition tape. In the park next to your Brooklyn apartment, you sail down the granite stairs in bread crates trying to look balls-out. You nearly sheer off two fingers. You do pull-ups together on the swings—actually, you dangle. You and Josh decide it would be a good idea to walk and talk about friendship, the straight-jock-and-gay-writer type, and crack juvenile jokes

that no doubt earn you a quick dismissal from Casting. These kinds of audition tapes, you will come to learn, are wastes of time. No show wants people who are ironic about their participation, who might test the comfortable lies of production: the negotiated presence of cameramen, the coercions of unseen producers.

Months later, you get a call from the friend of a friend. It's the summer you turn twenty-eight, and you're living on an island, alone with the cats, doing boat carpentry. The magazine that employed you went under and you decided to pull the rip cord on your life and relocate. The friend of a friend says that the show, the *Survivor* killer, got into trouble with their game engineering. Contestants went rogue on season one—hoarded cash, skipped stopovers, and took cabs instead of trains. Now, as they're trying to fix everything in the edit, the show's executive producer has decided to hire a team of game designers to avoid these problems in the future. Since no one has done this kind of thing before, apparently your eighth-grade summer class in game design sounds like the RAND Institute to these LA people. Are you willing to come out to the coast? You can make four times what you are making on the band saw setting bungs into screw holes. You might even get a trip around the world out of it. The Izod professor, the one inside you, says *Hells yes*.

The show operates out of the former offices of a defunct dot-com in Marina del Rey; what's weird is that nobody has changed the furniture, and a pipe-dream mood haunts the space. There's a fairway teacup from an amusement park ride in the front office. All the desks are planks in a long room, and at the back lurk the dark caves of editing consoles, where the

season one triage is taking place. The executive producer is this older Dutch fellow whose skin is eroding in the Southern California glare. Often, he has a Band-Aid across his face, which nobody mentions. He used to run *Cops*, and people treat him like a god because *Cops* is "syndicated as fuck." His much younger, beautiful wife transits the office like a visiting dignitary. She came up with the idea for the show, has executive producer credit, but does nothing except get looked at.

As part of the preproduction team for season two, you spend your days coming up with gimmicks. Already, the trip route has been decided, so you are given countries and it's your job to research and pitch possible activities—mystery caves, little statuary-finding missions, canopy zip-lines. Everybody loves zip-lines, they make great TV, but they have this problem: the race stops. No team can pass another team. It's what's called the accordion effect. When you bring this up in the meeting, the executive producer looks at you and says, "Who the hell are you?" You tell him and he says, "Well, then, let's just have them make sandwiches!" You can't tell if he's joking or brainstorming or what. Notes are taken. What's clear is that the show isn't really about gaming—it's about conflict engineering, ways of getting people to reveal themselves. Soon enough, you're calling McMurdo Station, on Antarctica, to see how long human skin can be exposed to the chill. Would it be possible for people to make igloos in jeans? The woman at McMurdo says, "Who the hell is this? Where are you calling from?"

"I'm from TV," you say, like it's an answer, like it's a place.

In the entire city of Los Angeles, you have one friend and she sits across from you every day. Katie drives a pickup with

a surfboard in the back. Often, she comes to work wet, having surfed already. She wears this knee-length cardigan that she clutches to herself like she's a refugee. When you ask her if she ever considered modeling, she says, "Shut up." After renting a convertible Jeep for a month—and getting the worst sunburn of your life just commuting to work—you buy a used Honda Accord and Katie takes one look at it and pronounces it lame. She is right. You always go out to lunch together. After a couple of months, Katie tells you that firings are coming. The show is about to go on location, and production for the race will start, which means some people will get tickets to fly around the world and some people will be let go.

"You're going to get cut," Katie says. "You don't have production experience."

You tell her you can guard a clue box in Brisbane or Cotopaxi as well as anybody. The entire *point* of this boondoggle in LA is getting a trip around the world. You have actually reported from abroad, *which is way harder than dealing with a clue box!* Katie shrugs and downs her taco. "Look, I'd quit if I were you," she says. "Don't let these tools fire you. Keep your fucking dignity."

Except that you have no income, no prospects. You don't even have your own apartment, anywhere. You have been crashing on the friend of your friend's floor. Quitting would mean free fall. Then Katie tells you a secret: She got into grad school, Columbia's International Something Studies program. As soon as the race ends, she's going to quit and move to Manhattan. The ridiculous television money she will make during production will cover her ridiculous tuition. You are happy for

her, but you also resent the coherence of her life. She's smart, beautiful, she has grad school and will be spending the next three months transiting the globe on CBS's dime.

Then you realize that Katie's dates don't work. Production is going to spill into her semester—she's going to ditch the race halfway for school. Make as much money as she can and then bolt. Which, if you were in her situation, is precisely what you'd do. Except you know that if she quits, it's a huge pain for the rest of the production team, trying to hire somebody from the road.

And so you scheme. All that training, in game theory, comes down to self-interest. This is what the professor and Richard Hatch have taught you: Self-interest and knowing exactly, if not more than, what your competitors know. The Nash Equilibrium proposes that a game will remain stable, with a neutral outcome, if all players choose for their own benefit and know the same amount. But you figure that if the producers knew Katie's plans, they might fire her before production starts . . . and a plane ticket to travel the world will open up. You'd be next in line. And so you stand on the blade of a choice: Do you choose to maximize your life? Or do you, by quitting, concede?

It doesn't take much to decide. One night, over drinks with the friend of a friend, you let Katie's plans slip. He is shocked. Katie is just the kind of steady, practical presence you want on the road. He was counting on her. He says he has to tell the executive producer. You had no idea things would move this fast. By the next day, Katie gets called into the main office. When she returns to her desk, she stares you cold in the eye.

"Can I talk to you for a minute?" she says.

You head outside, to that curb in the parking lot, behind her truck, where you ate all those tacos together, under that full-bore SoCal sun. She sits down. She fingers a rip in the elbow of her cardigan, where the knit is fraying. You stare at the back wheel hubs of her truck, surrendering to rust. Like all good reveals, what you now understand changes the outcome. You haven't just gamed her. You've undermined her escape. Columbia, the trip—they were her way out. She's as poor and lost as you are.

"Why?" she asks. "Why did you do it?"

You don't have an answer. You float a bunch of excuses—what's best for the show, some false loyalty to the friend of a friend—and she just shakes her head. You will never forget her shaking her head.

The next night, over drinks with the friend of a friend (all you ever seem to do together), you broach the subject of the trip. Now that Katie's getting fired, you wonder aloud if you they'll need somebody to fill in, someone with gaming experience and fresh eyes, who—

"Oh, they'd never pick you," says the friend of a friend matter-of-factly. "You don't have production experience."

Four weeks later, you request a meeting with the line producer and quit. "That's funny," he says, "because I was just about to let you go." You head out for a celebratory beer alone, at a gay bar in Silverlake. You have just enough money for a couple of months here, and by then, with luck, you'll find out who you are. It's haircut night at this place, and there's this line of men getting their heads shaved. Somewhere in the middle of the line is this fellow who looks like Poseidon. You

brave up, introduce yourself, and get his e-mail address. You decide no more games. You are going to be as direct as you can be and ask for what you want. Happiness and winning—two totally separate feelings, really.

You write him an e-mail. By this point, you know how it goes.

Except the next day, when you least expect it, he answers.

Game over.

12

THE AFTER-PARTY

John Albert

THERE ARE TIMES WHEN ONE CAN GLIMPSE something like a
passageway to hell. That is precisely the feeling I had watching
the reality show *Sober House*. It was as if a wormhole had opened
leading directly from my couch into a tawdry Hollywood where
troubled celebrities will humiliate and debase themselves, even
risk death, for one more moment in the spotlight. Throughout the
years, I have witnessed on-screen murder scenes and televised
surgeries, even watched multiple seasons of *The Real House-
wives of Orange County*. But this show genuinely disturbed me.
These were not bullet-riddled bodies or sunburned Republicans
with fake boobs. They were people I recognized, both literally
and figuratively, and it left me troubled.

The truth is, I have been addicted to reality television for years.
Until recently, I simply hid this fact. People would discuss what

they had done the previous evening, reading books or watching foreign films, and I would simply lie. I would tell them I had spent hours viewing savage Internet pornography or simply curled up in the fetal position weeping. Anything was more palatable than the truth: that I had sat for hours on my couch and watched reality television. And I'm not talking about the few socially acceptable shows like *Project Runway* or *Top Chef*. Like most addicts, I had long since turned to the hard stuff. In the early years, I was able to convince myself that watching seminal shows like *Cops* and *The Real World* was merely a form of social observation not unlike viewing documentaries such as *Nanook of the North* or *The Sorrow and the Pity*. That became distinctly less believable as I watched hefty actors being weighed on a giant egg scale during *Celebrity Fit Club*.

So what draws me to shows in which fading celebrities are humiliated for the sake of entertainment? Is it the vindictive pleasure of watching previously anointed ones tumbled unceremoniously from their thrones? That's definitely possible, and I'm not at all immune. There was a night in my late teens when I went to deliver a small parcel of cocaine for a local drug dealer. I arrived at the designated address and was surprised to find the homecoming king and queen of my high school huddled in an empty apartment, paranoid and nearly broke. Oh, how the mighty had fallen, I remember thinking, as I left with their last few dollars. I think for some people there is a similar jolt of superiority in watching a show like *The Surreal Life*, in which someone like Mötley Crue singer Vince Neil is reduced to performing in a childlike talent show with Emmanuel Lewis from *Webster*. I'm also aware that it could simply be my own sadistic tendencies. Fair enough.

But then, while watching *Sober House*, I suddenly hit bottom. Something felt noticeably different. The show, which is a spin-off of the series *Celebrity Rehab with Dr. Drew*, follows seven down-and-out celebrities as they attempt to stay off drugs while living at a sober living home run by radio personality and addiction specialist Dr. Drew Pinsky. The group consists of a porn actress, an *American Idol* runner-up, a rap rocker, an ex-model, Andy Dick, Rodney King, and onetime Guns N' Roses drummer Steven Adler—who, it should be noted, was actually kicked out of the legendarily debauched band for using too *many* drugs, which is like being asked to leave the Village People for being too overtly homosexual. By just the second episode, a mumbling Adler is hauled off by the police for being high and in possession of heroin. Soon afterward, the buxom ex-model gets drunk and passes out at a hockey player's party, and the singer for nineties rap-rock band Crazy Town (hit song: "Butterfly") begins openly smoking crack.

The reality of casting down-at-the-heels celebrities lends *Sober House* an added conflict. The cast is battling both their addictions and an almost inevitable slide into obscurity—a premise that hasn't always generated an outpouring of audience sympathy. When Vern Troyer, the diminutive actor known for playing Mini Me in the *Austin Powers* films, careened drunkenly around the *Surreal Life* house in his Hoveround and then peed into a closet, it didn't exactly register as an anguished cry for help. And sometimes televising a celebrity's struggles has an entirely negative effect. *Breaking Bonaduce* followed onetime *Partridge Family* star Danny Bonaduce as his life spiraled out of control with steroids, then alcohol, and

eventually an on-camera suicide attempt. The public reaction was one of surprising hostility. I know this because my friend Phil looks exactly like Bonaduce. When the show aired, Phil was subjected to much misdirected criticism. If strangers stare at him for even a second, Phil would reflexively scream, "I'm not Danny Bonaduce!" When Phil once met the real Bonaduce, he says, the troubled actor walked over and hugged him before he could say a word.

Perhaps the reason *Sober House* affected me, when other shows couldn't, is that I can relate to that world. After finally kicking drugs and alcohol for good back in the eighties, I actually did a stint working at a rehab facility. I know well the insanity of those places. Besides the near-weekly drug relapses, there was sex between staff and patients, more than one suicide, and an epic fistfight between two staff members after one insinuated that the other's girlfriend had been spotted at the "Toto house," a near-legendary site of cocaine-fueled hedonism owned by a now-deceased member of the popular soft rock band Toto. I also know some of the people on the show. Counselor Bob Forrest is an old friend from the LA punk scene. When I was sixteen, he watched, unmoved, as I took off my clothes and stumbled into a swimming pool while overdosing on quaaludes. In my world, that's like going to college together.

And while it's true that I haven't sung on *American Idol* like cast member Nikki McKibbin, or starred in a film called *Funbag Fantasies* like Mary Carey, I certainly did a lot of drugs and spent a lot of time in rehabs. I would like to believe I was vastly more serious about my recovery than the people on the show, but the fact is, I acted just like them. I used drugs in

every rehab except for the last, and once jumped out of a second-story hospital window (I was aiming for a tree) wearing a flimsy hospital gown and no pants in a desperate attempt to get high again. Nothing says stoic self-control like picking twigs out of your ass while trying to flag down cars.

A horror movie is really only as good as its monster and the same is true for reality shows. For many, the designated villain on the first season of *Sober House* was David Weintraub, the manager and then-boyfriend of porn actress Mary Carey. He's definitely a more subtle instigator then some of the classic reality villains. Puck on *The Real World: San Francisco* antagonized another character for having AIDS and getting too much attention. Spencer Pratt of *The Hills* represents everything wrong with humanity and makes me yearn for an all-consuming fiery apocalypse.

And as repugnant as Weintraub seems, I also find him fascinating. His air of superiority, and the fact that he openly dates his porn-star client—and insists on escorting her to a swingers' convention—epitomize a combination of avarice and unbridled hedonism in Hollywood. It's a topic that has obsessed me for years, and one I've observed firsthand. Years ago, I lived next door to a professional dominatrix. By pressing an ear against the wall and listening—something I did almost nightly—I could hear her doing unspeakable things to the clients who arrived nightly in their luxury cars. A sense of unwavering professionalism prevented my neighbor from divulging the names of those she bullwhipped, burned with cigars, urinated on, and dressed as adult babies—but she would acknowledge that most, if not all, were high-ranking studio executives, talent agents, and successful comedians.

Weintraub doesn't hide his ambition or his appetites. In fact, he doesn't seem to care at all what others think. On an outing with Carey and her housemates, he openly mocks the cast members as washed up has-beens. The fact itself couldn't be any great revelation to them, but actually saying it out loud is inherently cruel. Eventually his words appear to wound the Crazy Town singer, Seth Binzer, who embarks on a careening crack binge through Hollywood, all of which he conveniently records on his video phone for broadcast lest he lose any screen time. Weintraub is something of a reality TV renaissance man. He both produced and co-starred in a show called *Sons of Hollywood*, which followed him and his wealthy friends, Sean Stewart, son of rock star Rod Stewart and a *Celebrity Rehab* season two alumni, and Randy Spelling, son of television producer Aaron Spelling, as they simply, well, existed. He also appeared on the show *Date My Ex*—he was kicked off for baking obscene cookies and talking back to the host. And, according to his Web site, he is currently producing a series featuring fashion designer Christian Audigier, the man responsible for the steroid-abuser-friendly Ed Hardy and Affliction clothing lines.

I've long believed in confronting my fears, a tendency that has yielded mixed results. There have been some minor triumphs, but it has also landed me in jail, wasted years of my life, and given me a life-threatening liver disease. Regardless of the hazards, I decide I need to meet Weintraub and face my uncertainties about the reality television world. I locate an e-mail address and send him a note identifying myself and asking if we can talk. He agrees.

Days later, I arrive at a coffeehouse in West Hollywood across from the Ivy, a star-studded restaurant, and next door

to the Kitson store, which bills itself as the "home of celebrity shopping." It's a small stretch of street that has become ground zero for the swarming paparazzi and their mostly willing prey. Minutes after I arrive, there is a sudden commotion and a horde of photographers begin chasing an Olsen twin down the street. Weintraub soon saunters up with Mary Carey in tow. She is wearing a short black dress, stiletto heels, and heavy, overly dramatic makeup. It's an odd outfit for a casual cup of coffee— or for daylight in general. As we enter the restaurant, Carey takes out a small camera and begins snapping photos of herself.

Sitting down inside, I experience an odd feeling of familiarity—as if I've suddenly been transported into a not-yet-aired episode of *Sober House*. They, on the other hand, seem agitated. It turns out that they're not at all happy with Weintraub's portrayal on the show. Both claim that a pivotal scene was edited to make it appear as if Weintraub had called her a "stupid porn whore," when in fact it was the show's producer who said it. It's definitely possible: As anyone involved with reality shows can tell you, they're technically not reality. Beyond the practice of editing for story lines, many of the scenarios are set up by the producers in the hope of sparking on-screen conflict.

"*Sober House* is a complete sham," Weintraub says sullenly. "I've been getting a lot of hate mail. People think it's real. But *they're* the ones who called Mary a dumb porn whore. They decided to make me the villain, even though I helped them put the show together. People who know me watch this show and know that it's been edited and cut. The producers went out of their way to make me look bad."

I should probably interject here that, before meeting Wein-traub, I asked a mutual acquaintance if he was vastly different in person from how he appeared on TV. The answer was "Not at all." And this was from someone who claimed to *like* him. It makes complete sense to me. The first time I saw myself on television, I couldn't get over how radically the camera had altered my appearance, making me look older and heavier. "Were they using a funhouse mirror for a lens?" I had asked incredulously. They were not. It proved an important learning experience—one that led to months of severe dieting and an unfortunate dermabrasion incident in Tijuana—but I'm a better person for it.

I ask Weintraub if he thinks being on a reality show helps or hurts a celebrity's career. "For the has-beens, this stuff can't really bring them back," he says. "If it was the perfect show, maybe. But they really take these shows as a payday. They need the money."

Can you make much money doing a show about your own drug addiction?

"Each piece of talent is worth a different amount," he responds. "Mary here doubled her salary for *Sober House* because people were already engaged with her character [from *Celebrity Rehab*]. Before meeting you today, we were sitting down with the president of the E! channel. We want to do a show about sex addiction. Anna Nicole Smith really opened the door for Mary."

The Olsen twin enters the restaurant and walks past our table, looking out of breath. She disappears into a nearby rest-room.

Do you think being on camera is an addiction? I ask.

"For a lot of celebrities, definitely," Weintraub says. "They end up needing it. For instance, Mary Kate—who just walked past—knows exactly what she's doing. You don't come to this street if you don't want all that."

And I think that's really why struggling celebrities appear on reality shows. Beyond any need for money, they crave the spotlight. I've also come to believe that that's not necessarily a bad thing. Because a reality show star is still very much a star. There's an enlightening moment on the first season of *Sober House* when cast member Andy Dick is told that Weintraub has referred to them as has-beens. He looks around at the beautiful house and, I would assume, the camera pointing back at him, and replies, "If we're has-beens, I like this life."

I turn to Carey and ask her if she would ever do a show like *The Surreal Life*. Her face lights up. "I definitely wanna be on *The Surreal Life*," she answers. "I think I could be more myself. On *Sober House*, I feel like I should be crying every episode— and I don't cry very much in real life."

TREE MAIL TREE MAIL TREE MAIL THE TRIBE HAS SPOKEN THIS IS THE TRUE STORY OF SEVEN STRANGERS PICKED TO LIVE IN A JUST A REMINDER HOUSEGUESTS YOU'RE IN, OR YOU'RE OUT EITHER YOU'RE IN, OR YOU'RE OUT SEACREST OUT SEACREST OUT THAT'S TOTALLY RANDOM THAT'S TOTALLY RANDOM STEPHEEEEEN! STEPHEEEEEN! KEEP DANCING ON THE BAR SLUT THAT'S SO FIERCE THAT'S SO FIERCE PLEASE PACK YOUR KNIVES AND GO BOYS ARE LIKE PURSES

13

I DREAM OF STACY

Helaine Olen

I AM NOT THE SORT OF PERSON one expects to develop a love of makeover shows. I am a self-styled serious sort, a feminist who graduated from Smith. I read *The Nation* and *The New Republic* while on a treadmill at the gym—which I use only because my doctor ordered me to start exercising more regularly. I believe that laugh lines add character to one's face, and that plastic surgery is, if not a conspiracy against women, certainly a sign of a capitalist society run amok—that someone has found a new way to make a buck by convincing women that getting old is simply wrong.

It's not that I don't appreciate life's niceties. I like sundresses and A-line skirts, and a good find at the Barneys Warehouse Sale can make my month. But as for the rest? My makeup sits in a bag in my bathroom, mostly unused except when I have an

important business meeting. If I blow-dry my hair (cut in a sensible bob) once a month, that's a lot. It's mostly a matter of time and laziness—there are so many things to do, so many books to read and movies to see and restaurant meals to eat, that who on earth wants to spend precious minutes on some ridiculous and largely unnecessary vanity?

And yet, ever since the day that the American version of *What Not to Wear* debuted on the Learning Channel in the winter of 2003, I have idolized, worshipped, and had what can only be described as a girl crush on Stacy London, the show's dark-haired hostess.

I want Stacy to come into my house and take on my wardrobe, with my too-long beautiful orange wrap dress that I haven't had hemmed in the two years I've owned it and my ripped black skirt—the one that was baggy in the best of circumstances, whose condition I justify by claiming "I can wear it with leggings underneath and, anyway, it's comfortable." I want her to spy on me while I try on impossibly unsuitable clothes in East Village boutiques, clothes designed for the hip boho chick I always wanted to be and never was.

I then want to be whisked off to Nick Arrojo's studio and have my hair professionally tended to while someone whispers in my ear that my face would look, well, so much more elegant with just a few light layers around the face. I want Carmindy to pluck my always-scraggly eyebrows into a perfect arch. I want Clinton—my new gay best friend—to approve of it all, and then I want to have a great party to celebrate it before I go off into my perfect new life, the one in which I always remember to dress in clothes that actually fit, my perfect skirts graze my legs at the perfect angle just above the knees, I don't have to

fear my children will use a new white turtleneck as a napkin, and I get my gray covered on a perfect five-week schedule and always remember to put on my new makeup products so that I look perfectly polished and fresh before I leave the house.

My downward slide into makeover madness actually began in the fall of 2002 with *A Makeover Story*. One morning, pregnant with my second child, nauseous and dizzy, beached on the couch like a flannel-covered whale, I heard something like this: "And after the break, the two lifelong friends will be ready to debut their new looks at a party their pals have arranged especially for them." Mildly curious, I decided to stick around. As the two rather ordinary-looking women—with perfect hair, perfect makeup, and dressy clothes—walked into the celebration, I heard one of the friends say, "She's never looked this good in her life."

Lying on my couch in a battered nightgown, I wanted to look better than I ever had in my life.

Until that moment, the entire reality show industrial complex had almost completely passed me by. *Survivor* bored me; I found the Machiavellian machinations of the contestants as exciting and thrilling as being stuck in an elevator with a group of cutthroat and not-so-smart ninth grade girls. My idea of good reality show television was 24/7 coverage of the death of Princess Diana, or whatever John Edwards was up to with Rielle Hunter and her infant at the Beverly Hills Hotel at three a.m. In other words, I like crap TV as much as the next person, but I was loath to cop to it—unless it was gussied-up up with a CNN or MSNBC logo. That's how *A Makeover Story* wiggled past my intellectual and feminist pretenses. It's told in the style of a faux documentary—just the sort of thing that would appeal

to someone like me. There is voice-over narrator who follows two self-selected friends as they receive a joint makeover, often to commemorate a special occasion like graduating from college. The language is gentle and helpful: "Sutton's shoulders are narrow and she needs some help selecting the right jacket to show off her looks," a stylist might opine. Even the friends they interview about the subjects are primarily supportive. Most say something like, "It would be nice to see Mary wear clothes as beautiful as she really is."

There are people who sail glamorously through pregnancy, skin glowing, not suffering for even a moment from exhaustion, nausea, heartburn, back pain, and swelling. I am not one of them. Within a week of missing my period, I was horrifyingly, stupefyingly ill. My pregnancy routine: Wake up, feel nauseated, nibble the crackers I've left on the side of the bed the night before on a Fiestaware salad plate, which will give me just enough energy to get out of bed and over to a toilet, where I will promptly expel said crackers. Then hobble into the kitchen and nibble cold french fries stashed in the refrigerator the night before by my husband. These will stay down, leaving me with just enough energy to take a shower, change into a fresh pair of pajamas, walk back into the kitchen to grab another handful of fries, and hobble to the couch in the living room, where I will settle in front of a television for the next several hours.

And yet, in this state, I wanted people to see me as beautiful. I don't care how many times Demi Moore or others pose naked while pregnant on the covers of major national magazines. I don't care how many women take casts of the babies in their bellies, or coo longingly over newborn clothing at the Gap

while being filmed for *A Makeover Story*'s companion show, *A Baby Story*. Pregnancy isn't pretty—for me, at least—and it sure as hell isn't sexy. If you're in any fundamental doubt about this, ask any pregnant woman who has had the misfortune of taking a subway while, say, eight months pregnant and ask her how many men have offered her a seat on a crowded train car—or even glanced in her direction.

Women on makeover shows don't throw up in toilets. Or in bowls placed next to the couch they're resting on. Or in sinks. They don't gag in the street when walking their child to and from nursery school. They aren't too tired to show up for their makeover. They don't suddenly gain weight in odd and uncomfortable ways.

Makeovers, I decide, are my version of the sweet life. *A Makeover Story* led to *Ambush Makeover,* which led to home makeover shows like *Designers' Challenge* and *Landscapers' Challenge* and *Trading Spaces*, where best friends or neighbors are given an opportunity to redo a room in each other's homes. (Helpful Hint from Helaine: Letting your pals give your home a makeover on a low budget is not conducive to long-term friendship.)

Those led to *What Not to Wear.*

What Not to Wear began life as a BBC production in 2000 with two fantastically sarcastic hosts, Trinny Woodall and Susannah Constantine, who specialized in giving frumpy British women from the hinterlands new, fashionable lives. It was a monster hit in Britain, and a cult sensation on BBC America.

What Not to Wear is the anti–*Makeover Story*. It's not—at least at first viewing—a heartwarming show. Friends do not appear together, preparing for a special event. Instead friends

fink each other out—to Stacy. They write in, begging Stacy and her co-host (first Wayne Scot Lukas, then Clinton Kelly) to take on their loved ones and fix their fashion sins. "Mom dresses like it's still 1979," some ungrateful daughter might say. "And that's when she doesn't look like an unmade bed." The voice-over narration will take it to another level: "Susie thinks she looks like a Dancing Queen," it will intone. "But in reality, she's a one-hit wonder that never was from another era that's best forgotten."

The *What Not to Wear* crew stalks their unknowing victim for two weeks, filming them in the unpardonable acts of wearing baggy T-shirts, leopard-skin prints, rainbow-striped leggings, and assorted fashion disasters before confronting them with the videotaped evidence of their inappropriate awfulness.

Helaine leaves the house only to take her son to nursery school or to pick up more french fries at McDonald's, but that's no excuse for dressing like a welfare mom waiting for her next check. She's wearing a ten-year-old, vomit-stained, ripped flannel Lanz nightgown left over from her college days, with pregnancy leggings from Bloomingdale's that are too long for her petite frame under her eight-year-old coat.

I loved it. I thrilled as Stacy and her co-host went through her victim's wardrobe in front of the unforgiving 360-degree mirrored dressing room the show would become famous for, making nasty comments about her hapless subjects' favored outfits. "Are you seeking the lead role in *Auntie Mame*?" she might ask as she tosses a pair of mules with pink fuzz froufrou on them straight into the garbage. "Why would you buy this?" she'd shout as she added a sweatsuit to the pile. "Do you aspire to look like a bag of laundry?"

Lanz nightgowns? They have a name? My nightgowns that look like burlap sacks with plaid décor have a name?

Stacy and her co-host would then explain what their subject should be wearing based on age, profession, and body type, and send them off with $5,000 to purchase a new wardrobe—one they will buy with Stacy and her co-host watching over them via remote camera. Inevitably, the shopper makes a ghastly mistake—giving in to such temptation as, say, a zebra-striped blazer—prompting Stacy and sidekick to race out of the studio and to the store to help her finish the shopping expedition successfully.

Then she's whisked off to a salon for cut, color, and makeup application before modeling all for Stacy, who has now transformed into a doting and approving mother, clucking over her hatchling's newly formed taste.

I wanted Stacy's approval. As the nausea of my pregnancy slowly passed, I made efforts to take care of myself. I tracked down a line of inexpensive but cool-looking pregnancy clothing called Japanese Weekend that I recalled from my first pregnancy—the one in Los Angeles—and began ordering them online. I discovered a colorist who used vegetable dyes, and did something about my gray roots. I found a wonderful woman who worked near my mother's apartment to tame my forever bushy eyebrows so I could drop my son off and let her work on me at leisure, and not just do a rush job while he napped in the stroller.

The feminist within me should have been horrified. Instead, I loved every minute of it.

At first, I rationalized all of this by telling myself I could be worse. I could have watched *Extreme Makeover*, which took

the human redo to a whole new level. Not content to arrange for new wardrobes and hairstyles, the subjects on *Extreme Makeover* were whisked off to Los Angeles, where they received substantive plastic surgery, tough-love exercise programs, and serious mouth work in addition to the standard clothing and beauty styling. *You're a failure,* it seemed to say, *because you inherited your father's chin. There is little you can do for yourself. The professionals need to do it all for you.*

Extreme Makeover gave me the creeps. Stacy, on the other hand, inspired me. See, Stacy thinks you are fine just the way you are—that all you need is a little more attitude and some can-do spirit. She's the Simon Cowell of fashion, quick to make a quip at your expense, but really, really doing it for your own good.

What I hadn't realized—until my head was permanently attached to a toilet—is that I had grown arrogant about my appearance. I coasted on the fact that I was young and pretty and thin, and assumed it would last forever. It doesn't, of course. Women handle the discovery that youthful looks come with an expiration date in all sorts of different ways. Many completely surrender, giving up on all forms of vanity. You see them throughout my suburban town, with their sensible Peter Pan haircuts and colorless and shapeless unisex clothes. Others go in the opposite direction, running up tabs at the dermatologist's office for regular injections of Botox and Restylane, until they begin to look like stone-faced caricatures of their once-upon-a-time selves.

Stacy serves up tough love, but she never concludes that you're hopeless without medical intervention. She's the television equivalent of comfort food—if you like your comfort food with lots of garlic (and I do). When Stacy recommends a better-

fitting bra "to show off the girls," she doesn't point out that uplift surgery would have a more profound, effective, and dramatic effect. She might insult your clothes, tell you your makeup is fit for a seventeen-year-old about to go out on prom night, but she'll never suggest you lose weight—even when such an idea is blindingly obvious to the audience at home.

Under Stacy's tutelage, I've slowly learned to embrace the me that I am today. I don't need to give up completely and dress like a junior version of my two boys—but neither do I need to turn myself over to *Extreme Makeover*, where they would uplift the breasts that fed two babies and tuck the stomach that had held them. There are clothes and makeup that will make me look better and, if it takes a new hairstyle or a commitment to keep my gray covered—well, I'm a big girl. I can handle it. And Stacy knows that. She likes me just the way I am—well, sort of, that is.

Now if I could just make the time to get that orange wrap dress hemmed.

14

IDOLATRY

Richard Rushfield

"I'M PROBABLY THE ONLY PERSON who has ever told you this, but I have never seen an episode of *American Idol*." Once I became the official *American Idol* critic for the *Los Angeles Times* two years ago, I was told this approximately every time I stepped out of the house. At a typical party, five to ten people will seek me out to tell me they are the only person I've ever met who has never watched *American Idol*. In the cafeteria at work, a line often stretched for blocks with people there to break this news to me.

These confessions were all made with the same looks of smug but tearful bravery, the person nobly fighting to keep his or her chin held high in the face of horrendous persecution. It's the kind of thing one more typically finds on someone who believed that they were the only one in America who dared to call

George Bush a liar and who thought that, after having uttered these words, they'd be instantly spirited off to Guantánamo, where they would die a tragic, lonely hero's death in a rat-infested, moss-lined, airless hole deep beneath the earth. These brave souls thrusted their chins forward, their quaking upper lips fighting back tears, certain in the knowledge that I, as a representative of cultural imperialism, would respond to this heretical declaration by reaching for my cell phone to alert the authorities that the man we'd been looking for was standing right in front of me, slice of pita bread dipped in artichoke spread in hand, ready to face a nation's perverted justice.

I have never insisted that my friends and acquaintances toss roses at my feet to celebrate the various jobs and careers I've sailed through in my days. But in liberal-minded Los Angeles, people can show up at dinner parties and announce that they're heroin dealers or that they whip men for money or that they specialize in piercing obscure body parts, giving legal counsel to notorious murderers, or procuring transsexual prostitutes for celebrities, and nobody bats an eye. So it was with no small amount of shock that I realized I had apparently stumbled upon the one profession—*American Idol* critic—that had the ability to make you a complete pariah in society.

Among the common responses when people hear my secret:

- Aren't you ashamed to even watch that?

- *American Idol* critic? With all the illegal wars we're involved in, the criminals that have run our country—all the things that the *LA Times* ignores—they hire an f-ing *American Idol* critic?

- **It just shows you what a sorry state our country is in that people would take that show seriously.**

The last comment was generally followed by a rant about how American culture is destroying the world. By the time I got out my protests that the show is not particularly American (it's an imported reworking of a UK hit, jointly owned by a German media conglomerate and a British management firm, overseen by French and British producers, built around a British star), I was usually sputtering to myself as my accuser walked away shaking his head in disbelief that someone would dare defend such drivel in his presence.

And all I had set out to do was write an occasional review of a little TV singing contest.

In truth, however, since I donned the sparkly mantle of *American Idol* critic, my emotional involvement in the show traveled beyond that of a normal person. In my three years on the beat, I went deep down a very long, dark rabbit hole with America's leading entertainment provider. The scorn of my peers was all the more stinging for the fact that, despite my blasé demeanor, during the five months of the year that the show was on the air, I was no longer capable of conversation about anything other than *American Idol*. Despite my constant insistence that *American Idol* isn't destroying our culture, my obsession with it grew so great that when people tried to talk to me about other subjects—family, the economy, sports, ballet, quilting—I became impatient and quarrelsome. When friends had the temerity to chat with me about the upcoming presidential election last year, I would start hopping back and forth on

one foot, dying inside as I wondered how long I would have to endure such tedious trivia.

I had not meant for it to go this way. My wife and I had stumbled onto the *Idol* train as casual viewers in season five, tuning in from time to time to watch in horror the unstoppable rise of *Idol*'s kitschiest champion—buffoonish soul crooner Taylor Hicks. In early 2007 (season six in *Idol* time), I signed on to write an occasional review of an occasional episode. I was still quite capable of talking about all sorts of subjects beyond why Jordin Sparks's song choice in Barry Manilow week was secretly the most ingenious maneuver in television history. I had interests, hobbies, and opinions on the affairs of the world that had nothing to do with a singing contest.

Covering the show for the paper, I began in a bemused, offhand tone, handicapping the chances of this or that singer as a weekend visitor to the racetrack might discuss his ten-dollar bets. At the invitation of the Fox network, I began to attend the show's tapings and glibly offered my readers some tidbits from behind the scenes—whether or not the judges seemed to actually like one another, what the contestants did during the breaks. Nice pieces written in a breezy, tongue-in-cheek style that led few to question my grasp on sanity.

But then something changed. And this is what I think it was: I sat in the studio and watched time and again as, thirty feet away, a parade of young people dangled in tension more harrowing than anything produced by a presidential election or horror movie. Inches before me, adolescents and twentysomethings taken from absolutely nothing stood on the very brink of being handed the greatest treasure American society could give—true, lasting (so long as they played their cards right),

durable fame. Or, on the other hand, they'd be flung back into the dank swamp of anonymity from whence they came. Each week, I watched them stand alone on a cold empty stage and, in ninety seconds of singing, attempt to convince a pitiless nation that they deserved its love forever. I watched them stand alone, utterly unprotected after having poured themselves into a Faith Hill ballad, hanging by a thread as the judges systematically ripped apart their song choice, arrangement, delivery, eye contact, energy level, hair, makeup, leggings, and hair clips. And then, the following night, they would stand once again alone as the angel of death in the shape of Ryan Seacrest descended on them and revealed whether oblivion forever would be their lot, or they would come a step close to achieving the kingdom.

And witnessing the magnitude of that sheer unadulterated anxiety, seeing the brave souls as they faced this moment before a nation, stripped my ironic smirk away, my soul harrowed to its core as I had to ask myself: What is drama if not this?

When I speak of the awe-inducing spectacle of watching these young warriors sing their hearts out while teetering on the precipice of destiny—well, that's usually around the point when others at the dinner table start giving my wife looks of pity and one another glances of "Is he okay?" You can anguish about the fate of the Boston Red Sox in the American League pennant race, pull the hair out of your head over the outcome of a presidential campaign, and moan like a dying animal over the cliffhanger on *Lost*, but if you suggest that the fate of the world hangs on whether the seventeen-year-old balladeer or the twenty-six-year-old bar rocker is chosen as the next American Idol, you are, apparently, no longer fit for decent company.

And yet, the outcome of *American Idol* is of far more consequence than anything listed above. (We are selecting the background music of our lives—what could be more important than that?) I also believe that it's far more *dramatic* than any other competition, any other piece of mass entertainment or amusement in our culture, in human history.

Drama is about consequence, a small decision or turning point with implications that will ripple across a protagonist's life, creating tidal waves that will take years to dig out from. Achilles must decide whether to put aside his grudge against Menelaus, and on that hangs the Trojan War and the course of all Western civilization. David Copperfield has to find a way out of the blacking factory so that, instead of being a bleary-eyed bottle worker, he can grow up to invent the modern novel and stop Uriah Heep from marrying poor Agnes. Now and then, it's a nice change of pace to read a modern work where there is nothing at stake and no action has any discernable consequences. But by and large, the author's rule of thumb is that the higher the stakes, the bigger the drama; thus James Bond generally spends his time trying to stop some cartel from blowing up the world, not from pocketing a Three Musketeers bar at the corner grocery.

Now, when looking for material for high stakes, dramatists tend to fall back on a few tried and true motives. There is always love to dangle in the balance; while the hero sorts out his life, he risks losing the girl to the mildly creepy partner of a giant law firm. Tying the stakes of work to a competition over love has the advantage of casting the drama in a fuzzy glow that everyone can feel good about when love does conquer all in the end. Still, as perfect as the hero and heroine may seem for each

other—well, there are a lot of opportunities for love in the world, and once the disappointment of losing Jennifer Aniston or Emma Bovary fades, we all know that the hero could pull himself together and find someone else who may not present quite as many challenges.

The stakes can be money—as they are on every game show from *Jeopardy!* to *Survivor*—and while it's nice to see the hero get a big bag of loot, knowing that our leading man is somewhere out there $43,000 after taxes richer doesn't exactly make us feel warm all over. And besides, if a mountain of cash is going to be your punch line, it's got to be a really, really big mountain of cash. A million dollars isn't what it used to be in the changing-your-life-forever game—as we saw when *Survivor*'s first champion was carted off to jail for tax evasion.

And then there is power—political power, power over people, the power to do good. But that is just icky. Or way too earnest and dour to be the subject of a kind of art that anyone would ever want to see.

But there is one currency in our society with a value that's uncontestable, that's worshipped by young and old, rich and poor alike, that opens every door in the fifty states plus associated territories. There is one thing that drives even billionaires to memoir publishing madness and whose white heat holds our society in awe. Whatever cracks Warhol may have made about fame, its reign in America is stronger than ever, and it remains the asset before which all others stand in awe. And it is this resource that *Idol* alone can confer on someone like nothing else in human history.

The fame that *American Idol* offers its contestants is not the fifteen-minute flash-in-the-pan variety attained by guest stars

on *The Hills*, Olympic champions, or prostitutes caught with governors. *American Idol* takes at least one person each year and, within the run of a season, transforms him or her from a bank teller or waitress into a genuine, durable, built-to-last star. Consider the current first lady of country music (Carrie Underwood), the rocker with the biggest-selling debut in a decade (Chris Daughtry), and the woman who, on her first outing, both blew Beyoncé out of the water and won an Oscar (Jennifer Hudson).

And when Idols return home in the final weeks of the show, their cities turn out and greet them with parades. *No one* gets parades anymore in America. The finalists on *Survivor* don't get parades when they come home. Nor do the finalists on *The Bachelor*, *Dancing with the Stars*, *American Gladiators*, *The Biggest Loser*, or *A Shot at Love with Tila Tequila*.

The actors on *Lost* and *CSI*, much like the stars of *Speed Racer* and *Iron Man*, might be hounded for autographs, but a public undergoing an intense love/hate relationship with Hollywood-generated celebrity would not laud them like heroes. And, in any event, they don't *go* home. The majority of the entertainers whose faces adorn the covers of our magazines are there more to be reviled than worshipped. There are no parades when Paris Hilton and Lindsay Lohan come marching home.

Newly ascendant rock bands and pop stars certainly don't receive parades. Considering the fragmentation of music, they probably wouldn't even be recognized outside of their tiny demographic niches, anyway.

Politicians not only don't get parades when they go home but they also probably have to hide their faces from a substan-

tial portion of their local slice of polarized America. Heroes of the Iraq War may not be spat upon, but they aren't exactly celebrated, either. Go ahead, try to name one. Astronauts have become humdrum. Inventors don't leave their cubicles long enough to receive a parade.

A triumphant sports team receives a parade but its members, like solo athletes—from golfers to Olympians—so quickly license their likenesses to every product in sight (our adulation of them is harshly enforced by the marketplace) that a parade quickly becomes superfluous.

Which leaves *American Idol*. Only this show can harness a broad enough swath of the nation to command enormous crowds for their parades. And whatever their futures may hold, while they're in the rigorously protective *Idol* bubble, only these young people, nearly at the end of their epic, awe-inspiring journey, inspire the sort of unembarrassed, unironic affection that leads to masses of citizens weeping in the streets at the very sight of them.

And so each week, I sat in the Idoldome, at first sneering but then unable to scoff at the sight of these very young people, weeks away from working the drive-through line at their local Taco Bell, spending a minute and a half on a very large empty stage trying to convince the world that their lives should be about something bigger. In the balance hung, on the one hand, the fulfillment of their wildest dreams' wildest dreams and, on the other, a return to Taco Bell. If you can sit idly by and watch that spectacle, listen to the sound of a nineteen-year-old singing as though his or her life depended on it, and not be swallowed whole by the experience, then you are a stronger audience member than I.

Which is why, two years after I took on the assignment as a half-joke, I found myself strapped to a tattoo chair in San Diego, where the husband of one of the contestants marked me for life. At the end of the seventh season, I went out to follow the Idols on tour, much like my hippie classmates from college had done with the Grateful Dead. I had the thinly veiled explanation that it was for my column, but few who knew me well believed that anymore. During the seventh season, I had written extensively about Carly Smithson, the tattooed Irish songstress whom I declared repeatedly to be the greatest performer in *Idol* history. What struck me about Carly was not just her stunning vocals but her thrilling backstory, which made her *Idol* journey a deep and harrowing tale of redemption. Six years earlier, she'd come to Los Angeles as a seventeen-year-old singer, been signed by a major label, and was represented by the biggest management powerhouse in the business. But that experience led to sorrow when her label melted down before her album was released, leading to the record being dumped on the market with no support—a sudden, abortive-seeming end to her career before it began. In the years that followed, Smithson left Hollywood and moved with her new husband to San Diego, where they ran a tattoo shop and she waitressed and sang in a Gaslamp Quarter pub, dreaming of a return to music.

I watched as the Irish lass, who had come so close to giving up on her dream in those long wilderness years, fight her way back for one more chance. It was a real-life Cinderella story like nothing I'd ever witnessed. So when, at the end of the season, I finally met the resurrected singer, now on the road to stardom, it was a giddy evening. During a dinner interview

between myself and five of the *Idol* finalists, Carly and I discussed the upcoming tour. "You're coming to San Diego," she said. "You have to meet my husband."

"I'd love to!"

"And you have to see our tattoo shop!"

"I'd love to!"

"And you have to get a tattoo!"

"Ah! Well! Right, yes. Well!"

Let me parenthetically state not only that my body was at this date entirely unmarked, but also that getting a tattoo was as foreign an idea to me as growing wings and flying to China. Content in my late thirties with the notion that coolness was never going to be a part of my life, tattoos—along with skinny jeans, fauxhawks, and glitter body paint—belonged to a world I had reluctantly reconciled myself to never be a part of. Any accoutrements of this sort actually felt utterly alien, almost frightening.

All that said, after seeing the Idols in concert on that first night—a giant, sold-out show in Phoenix, Arizona—and remembering how far each of them had come, saying no to such dreamers was not possible. As much as I knew that this tattoo would subject me to permanent ridicule in my highfalutin circles back home, this was my own *American Idol* journey and there was no turning back.

Now, when friends gather and ask me about *American Idol*, I roll up my sleeve and tell them the tale of the long road that led me to the tattoo chair in San Diego, and they gape in horror at what my obsession with a television singing contest led me to. But at the end, when the tattoo is revealed, they are forced to strain their eyes to make out the tiny black dot on my forearm.

"It's a placeholder," I say, explaining how in the end, I couldn't quite make up my mind what I wanted to engrave myself with. With every telling, the story becomes undermined—the combination of obsessive insanity and cop-out wimpiness turns what admiration had existed to disgust and pity, even as I struggle to explain that it was still a major statement . . . it's my first one, after all.

Had I really learned anything from *American Idol*, there would have been no half-gestures, no apologies, and no explanations. But apparently my journey is still far from over.

HOW TO SURVIVE A
BACHELOR PARTY

Wendy Merrill

I RECENTLY WENT ON A *BACHELOR*-WATCHING BINGE. Although I don't like to think of myself as someone who would enjoy the show, I also don't like to think of myself as someone who would eat chocolate cake out of the garbage or sleep with a stranger while in an alcohol-induced blackout, so clearly what I think isn't nearly as important as what I do. I may have stopped drinking and binge eating some twenty years ago, but I happily hunkered down with my remote control to indulge in some real escapism.

The first thing I love to hate about this show is the premise—essentially, that it's possible to find true love on reality television. I mean, doesn't the idea of one man test-driving twenty-five beautiful women at once sound more like a polyamorous play date than an honest attempt at finding one's soul mate? But hey,

I guess that's hardly the point. We all know that reality shows are to real life what Pringles are to the potato, and *The Bachelor* is not exactly what I would call soul food. I guess I'm just a hapless—er, hopeless—romantic at heart, who resents myself for still wanting to buy into *The Bachelor*'s premise and believe in the *possibility* of a happy ending.

I grew up watching shows like *The Dating Game*, in which a bachelor would coyly ask three bachelorettes who were hidden from his view naughty questions like, "If you were a shellfish, what kind would you be?" At the end of the show, he would choose one woman, sight unseen, and they'd be whisked off to someplace fabulous like San Diego for a romantic dinner at the Red Lobster. Kind of sweet, right? *The Bachelor,* on the other hand, climaxes with what is essentially a booty call when the women who survived earlier cuts are each invited to go on a sleepover "date" with the bachelor. Each time the lucky couple entered the overnight fantasy suite, oohing and ahhing at the soft-porn-inspired candlelit room strewn with rose petals, all I could think about was how hard it would be to get those crushed-rose-petal stains out of the carpet the morning after.

The fantasy comes to an abrupt halt when all the final women save one get ceremoniously rejected on national television before being led by the recalcitrant bachelor to a waiting limo, where they're whisked away, shell-shocked and wondering where they went wrong. The camera closes in on their mascara-streaked faces as they berate themselves: "Was I a bad kisser?" "I knew I should have waxed my upper lip!" "If only I were a blonde, he would have loved me." One woman was so distraught about being rejected that she left the show in an ambulance after suffering a televised anxiety attack.

This show is so demented, it's awesome. Who dreamed this stuff up? Mike Fleiss, the second cousin of infamous ex-Hollywood madam Heidi Fleiss, that's who. At least Heidi didn't dress up pimping as love. When asked what the screening process for the women was like, Mike explained, "The women really have to want this. They are given blood tests, psych tests, and most importantly, [they] need to look good in a hot tub."

I understand why the producers might not want women with high moral fiber—after all, what fun would a slew of puritans be? And what STD-free emotionally stable hottie would want to live on camera, day in and day out, with twenty-four other beautiful babes all sharing the same bathroom—and the same man? I think the producers do a great job of casting (or at least editing them into) needy caricatures of women: I particularly liked the sequence in season one where a busty babe finally got the elusive bachelor to herself—and spent the whole time talking as fast as she could about how she'd read every self-help book in the world but still couldn't figure out why she couldn't make a relationship work. Just in case he was "the one," however, she had already purchased the eight yards of silk necessary to make her wedding gown. Way to reel him in!

And where do they find the guys? Supposedly, they search the country for the most eligible bachelors—successful and good-looking but, most important, ready to settle down. This got me thinking: Isn't a bachelor by definition a man committed to being single? According to Wikipedia, the term is often "restricted to men who do not have and are not actively seeking a spouse or other personal partner." Unless, of course, he is a "confirmed bachelor," and then he is simply gay.

The men aren't looking for fame or fortune; they're looking for true love. Well, except for season one's Alex, who auditioned for *The Bachelor* only after he failed to make it onto *Survivor*. And then there was season five's Jesse, the New York Giants quarterback who was paid six figures to appear on the show and left the playing field (after playing the field) for a career in media shortly thereafter. And let's not forget bachelor Bob from season four, who ended up getting sued by the show for using his *Bachelor* status to promote his "music." When his singing career didn't quite pan out, he kept the dating theme alive by hosting *Cooking to Get Lucky* (mDialog) and *Date My House* (TLC).

After thirteen seasons, none of the bachelors has married his reality TV sweetheart, but some appear to have found love as a result of their newfound fame. Andy (season ten) hooked up with the former Mrs. Trump, Marla Maples (reality TV is such a small world!), Matt (*The Bachelor: London Calling*) became engaged to his publicist Sarah; and good old bachelor Bob ended up marrying a soap opera actress who hosted some kind of "After-the-*Bachelor*" special.

As I fast-forwarded through season after season, I noticed that I really only needed to watch the very beginning of each show—when the previous week's dramatic highlights were re-capped—and the rose ceremonies. The giving of one red rose, in flower language, is supposed to mean "I love you," and rose ceremonies have traditionally symbolized the exchanging of love between a bride and groom. On *The Bachelor*, the rose ceremony is where reality sets in: this is when the bachelor weeds out the Mrs. Wannabes. The women (or girls, as they are always called) get all dolled up, Miss America style, in their prettiest ball gowns and Barbie heels. The bachelor picks up one red rose at a time,

calls out the lucky woman's name, and asks her if she'll keep it. By which he means, of course, will she stick around while he continues to date a bunch of other women? On the edge of our seats, we watch as hope fades in the eyes of each roseless woman throughout what is always described by host Chris Harrison as "the most dramatic rose ceremony *ever*."

As I watched, I couldn't believe that none of the women opted out of this humiliation-fest early on. Just once, I wanted to see a bachelor offer the rose, and the woman politely but firmly decline. I suddenly hated the idea that little girls who watch this show might believe that being picked or not picked by a man would be their only options in love.

Finally, in season five, two of the women raised their hands during the rose ceremony and asked to be eliminated. Bachelor Jesse looked pissed, but I was thrilled. Their explanation for wanting to leave was that there were other woman who were clearly in love with him and they deserved a chance. This sounded to me like the Miss Manners version of "Get me the fuck out of this house of crazy-ass bitches and away from this creepy guy." And it gave me hope for womankind.

There is one thing to be said for the ceremony: When a bachelor "breaks up" with a woman, he has to do it to her face. There's no hiding behind e-mail, cell phone, or the cone of silence. There's no way to not text a rose. And, as if that's not enough, the producers eventually bring the bachelor back to face all the rejected women in the *Women Tell All* special that inevitably follows.

After a while, I realized that every season was pretty much the same. The producers would change locations or add a twist every now and then to set the stage for additional drama, but

mostly everyone drinks (including, I'm willing to bet, the crew); the women continue to humiliate themselves; and the bachelor makes out with each girl and grows increasingly uncomfortable as his contractual "commitment" closes in.

What always happens in the end is this: A bunch of women get rejected, no doubt entering treatment for PTRD (post-traumatic rose disorder); one woman wins "the prize" (except in season eleven, when Brad rejected both); and the happy couple breaks up shortly after the media hubbub dies down. (With the exception of season six's Mary and Byron—although Mary was recently arrested for allegedly assaulting Byron in a drunken brawl, so tick-tock on that one.)

After watching five seasons in one week, I found myself on a first date saying things like, "Oh my gosh, you are *sooo* good-looking!" while clapping my hands and wiggling in my chair. I smiled much more than I normally would, batted my eyelashes throughout the evening, and conducted an interview with myself in the mirror after he left. (Question: "How did the date go, Wendy?" Answer: "I think we had a super special connection—he might be the one!") This was not good.

By the time I'd finished the tenth season, I had to restrain myself from giving the guy a lap dance on the second date. I wasn't even sure I liked him yet, but I felt a compulsion to seduce him to fend off my competition, real or imaginary. *The Bachelor,* apparently, wasn't designed to be consumed in mass quantities. It should come with a black box warning— "DANGER: Watching more than ten episodes in a twenty-four-hour period may cause severe side effects including memory loss, drowsiness, compulsive shopping for bridal lingerie, and an uncontrollable desire to pole dance."

I knew I was in big trouble. I needed to be deprogrammed, pronto, or I'd end up on a Dr. Drew special. I glanced nervously around my living room for the *Intervention* cameras. What was the antidote for overindulgence in romantic fantasy? One bolus of truth serum, *stat!*

That night during my post-date interview in the mirror, I got all Barbara Walters on my ass and decided to ask the really tough question: Why did I love to hate this show so much? Was it the way women were pitted against one another, or the sleazy players they picked for the bachelors, or the ridiculous premise? But I already knew the answer: What I hated the most was the fact that the women's happiness appears to be wholly dependent on whether or not they're chosen by a man. And this got me thinking: How much of my life had been spent trying to appear as desirable as possible so that I would finally be claimed by that special someone?

The answer was a tough one. I loved to hate this show, because these women were me.

The next day, I threw *The Bachelor* DVDs in the trash. This reminded me of how I used to throw out binge food only to retrieve it later—but hey, it's about progress, not perfection. I bought myself a mixed bouquet of flowers, and arranged them, one by one, in a beautiful blue vase. After the last flower was in place, I pulled out the single red rose, walked over to the mirror, and popped the all-important question.

"Wendy, will you accept this rose?"

After considering my reflection, I tossed the rose on top of the rejected DVDs, smiled, leaned forward, and answered:

"Make that a forget-me-not, and you've got yourself a deal."

GYM, TAN, LAUNDRY

Mark Lisanti

ON DECEMBER 2, 2009, I did something that I never thought I'd do again: I turned on MTV. I'd abandoned the channel so long ago I can't even pinpoint the length of my viewership hiatus, but I have a vague recollection of a dating show in which a dim-seeming college guy standing in front of a garishly shrink-wrapped tour bus had the ability to swap an undesirable female partner for a new chance at love by pulling a chain that would then dump the entire pledge class of a second-tier sorority on top of him. At some point during the process of watching the smothered dude try to connect on a personal level with these lucky ladies while digging himself out from beneath their wriggling pile of supple, Michelob-Ultra-fed flesh so that they all could ride the bus to some all-expenses-paid

date at the Olive Garden, my cable box coughed up an on-screen alert: "Aren't you a little too old for this crap, Grandpa?"

Indeed, I was. I must've been, like, thirty or something, and far more age-appropriate crap awaited on broadcast television. And so I clicked away from MTV, swearing never to return again.

But then a show called *Jersey Shore* changed all that.

• • •

And what is this *Jersey Shore* I speak of? In the most reductive terms, it's merely an ethnicized *Real World*, a spin-off on the "seven strangers picked to live in a house until they all fuck/kill each other" formula that replaces the wildly successful Many Colorful Types of Asshole model (the Gay One, the Hick One, the African American One, the Mentally Unstable Tramp Who Will Cut You One, and so on) pioneered by MTV with a Just One Type of Asshole format. And that One Type, in the case of *Jersey Shore*, is the self-identified Guido—a subset of East Coast Italian American culture that is united in its love for summering on the beaches of New Jersey, wearing T-shirts with sparkly dragons on them, and pushing the boundaries of hair-product technology to new and exciting places. The rest of the show's concept—right down to the quirkily decorated house equipped with a fornication-ready hot tub and the constant, drunken fisticuffs with locals enraged by the sight of TV cameras—is identical to *The Real World*. But diverging from the old formula and opting for that Just One Type scheme not only helped breathe new life into a moribund form but also allowed the show's producers to cast deeper into the available talent pool, providing the viewer with a far more immersive

Guido experience. This decision, whether by design or dumb luck, helped produce the breakout stars *The Real World* had been sorely lacking (Can the average pop culture consumer name a single *TRW* personality since, um . . . the Miz? Trishelle? *Puck*?), who arrived, fully formed and pre-branded with amazing nicknames, as the ambassadors from Guido Nation: Mike "the Situation" Sorrentino and Nicole "Snooki" Polizzi. The Situation (so named for the rippling six-pack that once caused a stunned fellow Guido to proclaim, upon seeing his now-iconic, synecdoche-inspiring abdominals, "Now that's a *situation* right there!") quickly declared himself Man of the House, a title he wielded like a boardwalk strength-test hammer, barking at all comers to just try and ring the bells of Jersey's vacationing guidettes beter than he can. Bite-sized Snooki, whose stature-enhancing poof and generously displayed cleavage suggests Elvira in tanned-to-a-fine-crisp miniature, became an instant sensation because of an unfortunate incident—initially promoted heavily but cut by MTV prior to broadcast—in which she was punched in the face by a male gym teacher from Queens. These two instant megastars, supported by a host of capable back-ups (Bart-Simpson-haired wingman DJ Pauly D, nice-guy ladykiller Vinny, serial cold-cocker Ronnie, cute instigator Sammi, comically bazoomed Jenni "J-WOWW"), propelled the *Shore* into the national consciousness virtually overnight. And swept me up right along with it.

So how did *Jersey Shore* draw me in? I'd sworn off not just virtually every permutation of the classic Hanging Out with Douchebags genre of reality TV (a big, dysfunctional tent that now not only includes *TRW* and its imitators but also mutant

strains like *Keeping Up with the Kardashians* and *The Real Housewives* franchise) in favor of much more in-vogue dancing/singing/cooking/sewing competition shows. Initially, I thought it might be that I was finally ready, after that long absence, to watch some more terrible people get drunk and copulate, spurred on by the belief that these would be the drunkest and copulatingest terribles MTV had produced in years. But no, that wasn't it.

Then I realized: It's the Guidos, stupid.

• • •

About five minutes into *Jersey Shore*'s (*two hour!*) premiere, Italian American groups began to express their displeasure about the cast's embrace—nay exultation—of the term "Guido," considered by many to be a slur, as well as MTV's alleged exploitation of the group by reducing all Italians to an easily mockable Goombah stereotype. It's a complaint Italians have heard before, most recently after some people wrongheadedly decried *The Sopranos*, perhaps the greatest and most nuanced television show of all time, for depicting the culture as nothing but a bunch of tracksuited, pork-store-haunting, stoolie-whacking goons. As an Italian American who grew up in a New York suburb just north of the Bronx, among friends (if not family) who were recognizable, if distant, forebears of *The Shore* gang (in those days, it was B.U.M. Equipment instead of Ed Hardy), Pauly D's celebratory explanation of Guido-ness as "a lifestyle . . . being Italian . . . representing family, friends, tanning, gel, everything," was not just the last word on a minor controversy. It was an invitation to take an inventory of my inner Guido every Thursday night. This, more than the

drunken antics of some knuckleheaded kids let loose in a beach house festooned with several horrific combinations of the Italian flag and the silhouette of New Jersey, is what drew me in for the entire eight-week, nine-episode run. And when Vinny articulated the dead-simple "Gym, Tan, Laundry" formula in episode six ("That's how they make the Guidos"), I now had a framework through which to see exactly how my own lifestyle stacked up. Let's take each part of the New Guido Credo in turn.

GYM

The most instantly recognizable aspect of *The Shore*'s cast is the male roommates' maniacal dedication to their physiques. Only Vinny, a token softy but certainly a big guy by any reasonable standard, would not be able to credibly pass as a body double for *Conan the Destroyer*–era Arnold Schwarzenegger. The show's biggest star's nickname, as we've previously discussed, was born of an almost hermetic dedication to the whaling-upon of abs. Accordingly, the show's female cast members have repeatedly expressed visceral attraction to "juiceheads" (and their even more extreme cousins, "gorilla juiceheads"), a none-too-veiled reference to the chemical assistance one needs to realize one's full muscular potential. In this primary aspect of Guidodom, I am a spectacular failure; the closest I've come to a gym in about eight years is considering a discount Gold's membership in the fifteen seconds immediately following my discovery of yet another ad dangling from the handle on my front door, a decision-making process that ended with the 20-percent-off pitch in a nearby waste basket. When I lift my T-shirt—much more likely to bear the

name of some indie band than a creation from the fevered imagination of Christian Audigier—there is definitely a *situation* happening: one of shapelessness, hopelessness, and despair. In the mirror, my navel seems to be smirking at me with disappointment, whispering, "Not so good, bro," before I yank down the shirt to silence its condemnation.

We are not off to a great start.

TAN

As the *Shore* demonstrated over the course of its maiden season, the maintenance of one's tan is paramount; no one loves a pasty Guido. And so our new friends put in their time each day in a UV-ray-beaming womb. "The tanning salon, you don't miss . . . five, ten minutes later you got your color, you go do what you want the rest of the day," explained the Situation on the *Shore*'s reunion special. (Though one can overdo the tanning thing—Snooki's too-artificial coloration resembles that of a perfectly roasted Thanksgiving turkey.) Here, once again, I am lacking. Despite a natural olive complexion, I haven't had a proper tan since a trip to Hawaii two summers ago, and even that was an utter fiasco involving a partial lobster-level burn brought about by an utterly inept self-application of sunscreen. Too often, I settle for the incidental tan of the beach-phobic, which, while pathetic, is pretty easy for a writer to maintain through brief exposure to sunlight on procrastination trips to the coffee shop. Often, upon returning home to New York, I'm asked by family and friends, "Isn't it sunny in Los Angeles all the time? Why are you that color?"

Yeah, this is getting bleak.

LAUNDRY

Perhaps the most underrated aspect of the Guido formula, the daily laundry run, is nonetheless crucial; after a sweat-soaked night dancing at the club followed up by a soak in the hot tub, one needs to hit the laundromat to refresh one's supply of Ed Hardy shirts and swim trunks in preparation for another hard day of partying. There might be a temptation to cut corners with a liberal spritzing of Febreze but there's simply no substitute for a basket brimming with clothes fresh from the full complement of wash/dry/fluff/fold services. Cleanliness, after all, is close to Guidoness. And here, finally, I can claim something approaching Guido bonafides. Enjoying the relative luxury of a washer and dryer inside my home, I could, theoretically, achieve Full Guido Laundry status. Unfortunately, though, a daily running of the laundry gauntlet seems excessive, and I settle for more of a once-a-week schedule that keeps me well-supplied with fresh T-shirts, socks, and boxers—a compromise I think is more than acceptable considering the infrequency with which I spend evenings throwing down to dope beats. The dog seems pleased enough with this arrangement, even if I don't wash the tattered hoodie I write in as much as he might like. And so in this arguably least essential phase of the Gym, Tan, Laundry program, I claim a proud, albeit qualified, victory. That will have to be enough.

• • •

So what have we learned through the identity experiment that was my time with the *Jersey Shore*? That I am a spectacular failure as a Guido hopeful, often failing to achieve in a calen-

dar year what my GTL exemplars routinely accomplish in a single day? Indeed, I could whine about how my job is more difficult and time-consuming than the cast's seasonal work maintaining a stall full of Federal Boobie Inspector T-shirts, but is it, really? I could note that I'm at least ten years older than these kids, so how could I possibly be expected to keep up with the breakneck pace of twentysomething hedonism. Would that be the truth? I think I'd be far better served to adopt the Situation's attitude of brutal honesty, and realize right now that even with this simple model of Guido-ness laid out before me, I'm never going to be able to cut it. As Sitch himself might say to me, when I once again break my no-MTV vow to tune in for the inevtiable second season of *The Shore* in order to experience another summer vicariously through a cast that's now a year buffer, tanner, and cleaner than I can ever hope to be: The spirit isn't willing, and the flesh is weak-sauce.

17

CORRUPTED REALITY

Rex Sorgatz

"THIS LOOKS FAKE," says Cynthia with a hint of superiority.
Our limbs are entangled on the couch, but our eyes are focused
on the television.

"Yes," I say enthusiastically, thwarting her attempt to neg
me. "I suppose that's why I like it."

"But isn't this your life?"

It is deep into Sunday night, past the hour when HBO drops
its weekly smart bombs. Cynthia and I have been dating for
only a few weeks, but it isn't going well. The moribund conver-
sation preceding *Six Feet Under* needs rescue, so I begin to show
off my channel-surfing skills, a sport mastered only through
years of arduous college training. As she sighs in boredom at
my fickle clicking, I launch into a rant about how her on-
demand, TiVo-reared generation could see the extinction of an

entire art form, "the channel-surfing craft," and with it, "the frisson of random media."

"You have completely forgotten *the fundamentals*," I conclude with fervor.

Instead of staring at me, she gazes at the forty-six-inch plasma.

The tension intensifies when the remote stops on my current favorite show, *Cheaters*, which my irony-deficient amour describes as "for and about scumbags." It's early in the relationship, so I'm still trying to impress her, but I've now mentally concluded that we'll break up by the end of month. How could I date someone who doesn't appreciate the three-act technical masterpiece of *Cheaters*?

Act I: a query about infidelity posed by a television private dick.

Act II: an investigation into the affair recorded on camera.

Act III: a confrontation regarding the indisputable lechery, usually concluding in fisticuffs.

Even though I am convinced that *Cheaters* is what Shakespeare would make if he had access to hidden video cameras and crystal meth, perhaps introducing adultery on the fifth date is unwise. So I click on.

In the upper channels, in that area where *Iron Chef* reruns play tag with subtitled movies, I accidentally land on something called *Storm Watch*.

"Fuck, fuck, fuck, yes!" I gasp as a menacing *Storm Watch*

logo bustles across the screen. In a rare moment of almost-intimacy, Cynthia glances at me with a look questioning my elation.

"A reality show about natural disasters? Really?"

But I point to the tube. My face is on the television.

Cynthia is understandably confused. Trying to speak over my own voice coming out of the surround-sound, I quickly attempt to explain why a decade-younger version of me is glowing in the living room: After surviving a flood and fire many years ago, I was asked to do a video reenactment of my escape. We are now watching this very show.

"Is this a setup? Did you know this would be on?" she asks, as a whiff of postproduction smoke crosses my televised face.

"No!" I am shocked by her inability to find poetry in serendipitous media.

And that's when she says it: "This looks fake."

Now I really don't like her, but she is right about one thing: it does look fake.

● ● ●

Historically, mainstream pop entertainment has seldom been intentionally controversial. Disposable sitcoms, paperback novels, chick flicks—these are not natural fodder for creating deep societal embroilments.

Reality television may be the sole exception.

Arguably the schlockiest genre in the history of pop culture goo, reality television somehow provokes the most divisive discussions. Go ahead: ask someone what he or she thinks of *Real Housewives*, and you'll likely get one of two responses. The first is an impassioned critique of a character. And there's

nothing wrong with a glowing paean to NeNe, but this frothy response isn't particularly interesting—it's the contemporary equivalent of saying Madame Bovary had it coming.

The more likely response will be something along the lines of "I hate, hate, hate reality television." Notice your interlocutor didn't say "I hate that show." Rather, she waved her Ginzu at the entire genre. No one bothers to vocalize their disgust of, say, mystery novels, but invoking reality television is like opening the guffaw box. It's the universal polarizer.

To find out why, don't stop there. Continue with questions: "Why the hate?"

The answer is almost invariably some version of "because it's fake."

Ah yes, the fakery.

• • •

"I thought, *this is never gonna happen, this is not going to happen, they can't do this to seven people.*"

That's Eric Nies, uttering the first words on the first episode of the first season of what many consider the first reality TV show, *The Real World*. It is the summer of 1992. This show is set in New York City, but I am in the deep Midwest, where I was born and raised, and where I could only imagine probably dying.

Growing up in the middle of nowhere, before the Internet, I had no understanding of the size of cultural events. For all I knew, Bruce Springsteen could have been an obscure singer-songwriter and the Pixies could have been playing stadiums. So I didn't understand whether *The Real World* was actually significant, but it certainly felt like the most important thing

to happen to me in 1992. I was in college, but it was the first time in my life that I could imagine being somewhere else.

I lived with my kinda-best friend that summer. We were both taking classes at the University of North Dakota. His name was Chuck and he was probably the only person alive who was more obsessed with *The Real World* than me. We adopted the show's motto, "When people stop being polite and start getting real" as our own.

"Real," to us, meant arguing about everything.

• • •

If you believe that television has any influence over us, then you must sometimes wonder how the worldviews of people raised on *The Brady Bunch* and *Dallas* differ from those weaned on *Survivor* and *The Real World*.

And if you believe these shows can affect our personalities, then you must wonder whether the narratives of reality television bleed over into our behaviors.

And if you believe they can, then it seems logical to conclude that we are doomed to repeat these plots in our daily lives.

With that bleak conclusion, allow me to ruin the plot of every episode of every reality-based drama on television:

Person A says something to Person B about Person C. Person B then recounts the conversation to Person C ("that bitch, Person A!"), except it doesn't sound exactly like what Person X (that's you!) heard. Person C then asks Person D if she should confront Person A about what she told Person B. Person D always says yes—confront! By the time that Person C confronts Person A, Person X has heard the story several times, but it keeps changing with each telling. By the end of the episode,

Person X has completely forgotten what exactly Person A said to Person B, which is peculiar because Person X, like all the cast members, seems to overlook that this show is *videotaped*.

This is surprisingly similar to modern life.

• • •

Fifteen years after the first episode of *The Real World*, that same kinda-best friend from college published a semi-famous essay that described the summer we lived together. Still available in Urban Outfitters across the country (in a memoir called *Sex, Drugs, and Cocoa Puffs*—my roomie Chuck had become the writer Chuck Klosterman), the essay became pervasive in a way that is still mildly unsettling.

In his depiction, we drank an insane amount of Busch beer, argued incessantly, and watched every episode of *The Real World* at least three times. This was essentially accurate.

In another essay, he labeled me his nemesis. This was also essentially accurate.

He wrote a lot about that summer, but here's a single sentence:

Perhaps this is why we were both enraptured by that summer's debut of MTV's *The Real World,* an artistic product that mostly seemed like a TV show about people arguing.

All memoirs lie, to some degree. But nothing in Chuck's book is exactly *false*. I remember certain events slightly differently, but who's to say if my memory is better than his? That's not really the point.

No, it was something else that began to annoy me about his

account. When I reflected on my years in college, I started to realize that I often told the same stories that he told in his books. Over time, I began to forget other details from the summer we lived together. My girlfriend lived with us, but she has somehow disappeared from my memories of that year. I had a job mowing lawns on campus, but I can't recall anything notable about it. I took a Classical Mythology course that summer, but would probably lose a final *Jeopardy!* question about Prometheus.

However, I can remember with crystal-clear perfection the arguments that Chuck recounted in print—such as whether water has a discernible taste. (Shut up, it does not.)

Over time, Chuck's memories of that summer began to supplant mine. His version eventually became my version. I believe my nemesis stole my memories.

This pissed me off for a long time.

• • •

Not long after the *The Real World* became a yearly television experiment, a fourteen-year-old boy from Washington named Chris was asked to participate in a scientific experiment. He was given four stories from his childhood, all culled from his relatives. After reading the stories, he was instructed to recall the events and write about them every five days, offering any details he could remember. If he didn't recall anything, he was told to write "I don't remember."

One of the memories was about being lost in a shopping mall in Spokane, where his family often shopped. Though he'd been only five years old at the time, Chris remembered the event, describing the man who rescued him as "really cool." As

he retold the event, his memory became increasingly clear. He remembered being scared, and he remembered his mother scolding him for getting lost.

A few weeks later, Chris was told to rate how well he remembered the four childhood events on a scale from 1 to 11. (Apparently the researchers were fans of *This Is Spinal Tap*.) He rated them 1, 5, 8, and 10. The shopping mall story received the 8.

But the thing is, Chris never actually *was* lost in a mall. It was a story planted by cognitive psychologists, based on small narrative details supplied by his parents. Chris was part of a study that tested whether memories could be created by merely telling someone an event happened. It turns out they could.

The "Lost in a Mall" study was later reproduced on twenty-four people as part of a University of Washington study. One-fourth of them became convinced that they were also trapped in a mall as a child. Later, their family members all confirmed that none of them actually were.

• • •

Scene opens. A head is lying sideways on a couch. It occupies the entire screen. His eyes are closed. He might be dead.

Cut to firemen who are pounding down a door. "Fire! Fire! Get out!"

Cut back to the face. His eyes suddenly open, his head lifts. He reaches for his glasses, places them on his face, and runs toward the door.

"So that's you? Why didn't they get a real actor? Why do you look fat?" Those may sound like questions you'd ask a person, but Cynthia is speaking to the television, which at this moment is showing me being loudly awoken from a nap.

"Yes, I got to play myself in a video reenactment of my harrowing escape from a fiery inferno."

"Why have you never told me this?" she asks.

"Because it actually was neither very harrowing nor fiery."

• • •

So this is how it happened, pretty much:

On a warm April morning in 1997, I awoke and looked out the window of my second-story downtown apartment. Six feet of water was flowing through the street. It was not completely unexpected.

Most of the small Midwestern city had been under a mandatory evacuation zone for more than twenty-four hours. But I had decided to stay, because I am kind of an idiot. Every major news outlet showed up to chronicle what would become the largest evacuation of an American city in the twentieth century.

The next afternoon, as the water still flowed through the city, I was awakened from a nap by firemen yelling, "Fire! Fire! Everyone out!" The butts of their axes pounded on my door, and every door down the hallway, as they searched for stragglers. I was the only one in the building.

When I opened the door, they looked at me casually. "You have to leave," one said with little haste in his voice.

They escorted me to the outdoor fire escape. Two buildings down the street, I could see a small fire coming out of the top floor. "You can put that out, right?"

"Nope," replied the fireman. "This whole block is gonna go." I swear he nearly yawned.

"Why?" I asked back, trying to match his Midwestern nonchalance.

He pointed. On the opposite corner, I could see two firemen diving off a boat into the water with their fire hoses. Because the city was under water, there was no way to get to the fire hydrants. It was tragicomedy pulled from Leviticus or Deuteronomy or any of those books where God hates people but is funny about it: a city under water couldn't put out a fire.

At the base of the fire escape was a small boat. As I got in, the national guardsman asked, "Where would you like to go?"

"California," I said. He dropped me off at campus, about a mile away.

I found the only building on campus with television, where I watched my apartment, along with other pieces of downtown, burn down live on CNN.

A month later, a television production company called. "Would you like to do a video reenactment of your story?"

"Sure. It wasn't very scary, though."

• • •

If you dislike reality television because you think it is fake, then you *really* hate *The Hills*.

As a hybrid "scripted reality" show, it practically begs for its legitimacy to be questioned. The show's former blank-faced protagonist, Lauren Conrad, delivers lines with the speed and affectation of Vanna turning letters. Her nemesis, Heidi Montag, is better with the ad lib, but is still a less realistic cartoon than Jessica Rabbit.

But this is exactly why I love *The Hills*.

Media-saturated society is a messy place right now. Fake news is better than real news, Wikipedia is a definitive information source, and finding an image that hasn't been Photo-

shopped is impossible. Even social situations (superficial parties, opportunistic dates, coy Facebook chats) all seem like theatrical rituals in which the best performances are handed lifetime Oscars—or more Twitter followers. This makes life feel like a cluttered assemblage of confusing pseudo-events. I barely remember what it was like to have an unmediated experience, something untainted by advance critical hype or societal backlash. Everything feels suspiciously fake, like Neo felt before he took the red pill.

That is why *The Hills* is genius. It is the most *meta* show on television. When I'm watching *The Hills*, I am keenly aware that *I am watching The Hills*. I never feel that way while watching *Seinfeld* or *Scooby Doo* or *The Bachelor*. With other shows, I never think, "How did they get the camera into that bar?" or "Was that conflict scripted beforehand?" or "How the fuck do Audrina's boobs hover like that?" Precisely because it blends elements of the fake and the real, *The Hills* makes me think more about its own *creation* than anything I have ever watched. And by making me ponder this faux-reality, I begin to think about how real world rituals are similarly artificial. When Spencer delivers a Rabelaisian line that seems obviously scripted, you can say that's fake—or you can admit that you save up material in the same way.

• • •

"Cut! Cut! Cut!"

The director has stopped concealing his annoyance. It is probably the tenth time we've tried this shot. All I am required to do is rise from my slumber and go to the door. The same firemen who rescued me a couple months ago are behind the door.

I keep messing up the scene, even though I have no speaking parts.

"Quit looking at the fucking camera!"

I want to yell back "Quit fucking yelling at me!" but I know he has the moral and logical upper hand in this situation. I truly can't stop looking at the fucking camera.

I would make a miserable thespian. This craft involves stepping outside oneself and becoming another person. I'm horrible at imagining the lives of others. Plus, I can't stop looking at the fucking camera.

We finally solve the dilemma by shooting from an angle that I can't look toward without really cranking my neck. It briefly solves the problem, until the next shot, where I am taken down a fire escape. We perform this bit of dialogue:

ME: Oh my god, the fire!

FIREMAN: This whole block is going to go.

ME: Why?

FIREMAN: We can't get to the hydrants. The levee has broken. We need to get you out of here. Now!

Every time I watch *Storm Watch*, I begin to remember more of the events from that flood and fire. I remember eating soup out of a can, and I remember standing in FEMA lines. The flames become more vivid, the water more treacherous.

But am I actually remembering? Or am I forgetting?

We live in an age in which large swaths of our lives are digitally recorded through photographs, video, audio, and text.

This seems to have somehow tricked us into believing our memories have also improved.

But now that I think about it, maybe my nemesis didn't steal my memories. Maybe I gave them to him.

• • •

"What do you miss most?" asks Cynthia, with seemingly genuine remorse.

"My books," I say without hesitation.

"Why?" she asks. "It's not like you un-read them."

"I realized something after the fire," I say. "When you no longer have these things around you, either physically or digitally, you forget about them."

"Forget?"

"Yeah, like they were erased," I explain. "In used bookstores now, I still find books that I completely forgot once reading. There's nothing around to remind me of them anymore, so I forget."

Cynthia thinks about this for a moment. Her soft, inquisitive face reminds me why I'm on the couch with her.

"What else is on TV?" she finally asks.

"There's a *Cheaters* marathon!" I cheer.

TREE MAIL TREE MAIL TREE MAIL THAT'S SO FIERCE GO PLEASE PACK YOUR KNIVES AND GO THE TRIBE HAS SPOKEN THE TRIBE HAS SPOKEN THE TRUE STORY OF SEVEN STRANGERS PICKED TO LIVE IN A THIS IS THE TRUE STORY OF SEVEN JUST A REMINDER HOUSEGUESTS EITHER YOU'RE IN, OR YOU'RE OUT SEACREST OUT SEACREST OUT THAT'S TOTALLY RANDOM THAT'S TOTALLY RANDOM STEPHEEEEEN! STEPHEEEEEN! STEPHEEEEEN! BOYS ARE LIKE PURSES BOYS ARE LIKE PURSES KEEP DANCING ON THE BAR SLUT KEEP DANCING ON THE BAR SLUT

DOG THE BOUNTY HUNTER HUNTER

Neil Strauss

"MARK BURNETT IS READY TO SEE YOU NOW."

"Great. Thanks. It was really generous of you to do this meeting. Sorry about all the phone calls. I just really respect your work."

"And I respect your persistence. That's why I told Meredith to give you five minutes of my time. So what's your great idea?"

"Okay, here it is. Sorry I couldn't e-mail it, but I didn't want anyone to steal it. My show is called *Dog the Bounty Hunter.*"

"There's already a show called *Dog the Bounty Hunter.*"

"I know. But my show is totally different. In my series, I hunt down Dog the Bounty Hunter."

"Why would you want to do that?"

"For his crimes against humanity."

"I'm listening."

"He's a terrorist. He terrorizes people. These poor, confused guys who fell behind on their alimony or did a few drugs—they're scared. They're scared of prison and what's going to happen in there. They're scared because they made a mistake. And what does he do?"

"He puts them in jail where they belong?"

"He hunts them down like animals. Him and that fat fucking bitch and his redneck shitkicker buddies. They yell at these guys and tackle them and call them dirty names, and then pat themselves on the back afterward like they're the second coming of Boss Hog."

"And so you're going to hunt him down because he's mean to criminals?"

"No. I'm going to hunt him down because he thinks he's better than them. I'm going to hunt him down because he's a self-righteous racist on a power trip and needs to be taken down a notch. But most important I'm going to hunt him down because he's a criminal. We have evidence, recorded for television, of him trespassing, breaking and entering, committing assault and battery, and kidnapping. He is the same as what he pursues. Possibly worse. And so I would like to put him down like the dog he is."

"Yeah, interesting idea. But I don't think it's right for us."

"How much time do I have left?"

"Three minutes, but—"

"Okay. Wait. I have another idea. Get this. Who's the biggest celebrity in the world right now?"

"Barack Obama?"

"Okay, but also Michael Jackson. Picture this: *Sleepover with Michael Jackson*. We take you behind the closed doors of

the Neverland Ranch for an inside look at Michael Jackson's life as you've never seen it before."

"Michael Jackson's dead."

"Exactly."

"Exactly what?"

"That's our loophole. Think about it: Because he's dead, he can't sue us."

"Yes, but because he's dead, he can't be in the show either."

"I'm one step ahead of you. We rent Neverland Ranch, get a Michael Jackson impersonator, and pretend like we filmed it before he died. It'll be the biggest television event of the year. In fact, we don't even need Neverland Ranch. We'll just sneak into Disneyland when it's closed. The networks will love it: no budget. Outside of hiring the impersonator. And the kids, of course."

"Not going to happen."

"Okay. How about *Megan Fox Gets Married*?"

"That could work. Tell me more."

"Okay. The show is, I get married to Megan Fox."

"And how's that going to happen?"

"We have a meeting. I pitch her the show. And she does it for the exposure. Think about it, all the spinoffs: *The Megan Fox and Angelina Jolie Threesome Hour. Megan Fox Gets Pregnant. Megan Fox Gets Dumped Because She Got Fat and the Kids Won't Shut the Fuck Up and She Acts Like I Don't Even Exist Anymore When I'm the Whole Goddamned Reason She's Even Had Four Seasons on TV.* Actually, forget about that last one. I got—"

"Next."

"Okay. You'll love this one. You know how everyone's done those *Teen Stars: Where Are They Now* shows? Well, we do

Elderly Stars: Where Are They Now? Like where are the guys from the *Cocoon* movies? Or we could do a reunion of the cast of *On Golden Pond*. Or what's George Burns doing these days? Is he a mechanic, a bodyguard, a pop star in Japan? People want to know."

"I think they're with Michael Jackson. The problem with your ideas is they're all about famous people. We're not looking to do celeb-reality anymore. Viewers want to see ordinary people whose lives they can relate to."

"Okay. That's why I've saved my best idea for last. *Still Life with the Normals*."

"What's that?"

"Let's see. I just liked the name really. Maybe we take six boring people, and we put them in six different houses. Then we see what happens. No one's ever done that before."

"I think I know why. Listen—"

"Not so fast. There's more to it. We can, um, add a contest to get people to watch every week. A World's Greatest Introvert Contest. People call in and eliminate the most extroverted person. Or, since they may be introverted themselves, they can text for like forty-five cents. Hello, added revenue stream."

"None of these are going to work. You asked for five minutes. I gave you five minutes. Now—"

"Okay, fine. Just hear me out. One more thing, and I'm out of your life forever."

"Last thing. Okay. Meredith, order me a veggie burger with olive tapenade on ciabatta bread, please."

"Okay. Here's the thing: why do people watch reality TV?"

"Why?"

"It's because it's real. It gives them what they feel is an

honest look into other people's lives and personalities. But it's not just that. They're not voyeurs. They're looking for something. They want to compare their lives to other people's. They want confirmation that they've made the right choices. They want to make sure they're not missing out on anything. So when they see celebrities who are miserable and supermodels who are crazy and rich people leading empty lives, they think, 'Thank God I'm not famous or beautiful or rich. I'm happy with me. Just the way I am.' "

"That's interesting. Go on."

"So here's my idea: *Beat Your Idol*. It'll be huge."

"What happens?"

"We find someone who's a big fan of like a pop star or an actor. And then they get to beat them."

"Beat them at what? A singing contest?"

"You mean beat them *with* what. They can use whatever they want. Like a riding crop or a steel chain or a pistol. Or whatever. It'll make them realize that they shouldn't look up to other people, and they can just—"

"Meredith, can you call security?"

"Let me just throw out some other ideas. Really quickly. I'm sure one of these will resonate with you. *John and Kate Plus Eighteen*, where they get back together and adopt some Chinese babies? *Project Runaway*, like a nationwide search for the most fashionable homeless person?"

"Meredith!"

"*Gary Coleman Modeling Agency? Extremist Makeover? Dancing with Condoleezza Rice? Big People, Little Beds? Survivor: Compton? Last Meerkat Standing? The Rapist Whisperer?*"

"Sir, you're going to have to come with us."

"Okay, okay. One second. *Who Wants to Bang My Wife? I'm in a Coma, Get Me Out of Here?* Let me go. I can walk out on my own. *Real Housewives of Kabul? Amazing Drunk-Driving Race?* Ouch. *So You Think You Can Deep Throat? Catharine MacKinnon of Love?* You're crumpling my treatment. *Paying Taxes with the Stars? Rush Limbaugh's My New BFF?* Hey, there's no need to be so rough. *I Wanna Work for the Green River Killer?* Seriously, that hurt. *Who Wants to Marry A Bald Broke TV Writer Who Lives with His Mom?* So. Wait. When can I expect a call back?"

He never called. I tried to reach him a few times a day for several years afterward. The guy was probably too busy stealing my ideas. This kind of thing would never happen to Dog the Bounty Hunter.

CONTRIBUTORS

John Albert grew up in Los Angeles. As a teenager, he co-founded the cross-dressing death rock band Christian Death, then played drums for seminal punk band Bad Religion. He has written for the *Los Angeles Times*, *LA Weekly*, *BlackBook*, *Fader*, and *Hustler*, among others. He has won awards for sports and arts journalism and has appeared in several national anthologies. His book, *Wrecking Crew* (Scribner), which chronicled the true-life adventures of his amateur baseball team—comprised of drug addicts, transvestites, and washed-up rock stars—has been optioned by studios three times so far.

Austin Bunn is a journalist, fiction writer, and playwright. His work has appeared in the *New York Times Magazine*, *The Village Voice*, *One Story*, *Best American Science and Nature Writing*, *Best American Fantasy*, *Pushcart Prize 2010*, and many magazines now dead to him. His screenplay *Kill Your Darlings* is being produced by Killer Films. He teaches writing at Grand Valley State University in Michigan.

Melissa de la Cruz is the *New York Times* and *USA Today* best-selling author of many books for teens, including the *Au Pairs* series, the *Blue Bloods* series, the *Ashleys* series, *Angels on Sunset Boulevard,* and *Girl Stays in the Picture*. She has

written for *The New York Times, Harper's Bazaar, Glamour, Cosmopolitan, Allure, Marie Claire, Seventeen, Teen Vogue,* and *Cosmogirl.* She lives in Los Angeles with her husband and daughter.

Jancee Dunn is the author of the 2006 memoir *But Enough About Me,* the 2008 novel *Don't You Forget About Me,* and the 2009 collection of humorous essays, *Why Is My Mother Getting a Tattoo?* She writes regularly for *The New York Times, Vogue,* and *O, The Oprah Magazine* (in which she has a monthly ethics column titled "Now What Do I Do?")

James Frey is originally from Cleveland. He lives in New York. His work has been published in thirty-two languages.

Amelie Gillette is a staff writer for The A.V. Club, *The Onion*'s semi-serious entertainment section, where she writes the popular pop culture blog and column "The Hater," as well as "The Tolerability Index." She lives in Brooklyn.

Will Leitch is the author of four books, *Life as a Loser* (2003), *Catch* (2005), *God Save the Fan* (2008), and a book about baseball and fatherhood set to be released in May 2010. He is a contributing editor at *New York* magazine and the founder of sports blog Deadspin. He lives in Brooklyn with his fiancée and many pictures of Albert Pujols.

Mark Lisanti is a writer living in Los Angeles. He's the founding editor of Defamer, a blog about Hollywood, and is editor at large at Movieline.com, where he writes about film,

TV, and the dizzying magic of Tinseltown. He's contributed to *Vanity Fair, Esquire, Rolling Stone*, the *Los Angeles Times*, and *Radar*. Though he grew up just outside of New York City, he has never actually been to the Jersey Shore.

Ben Mandelker is a Los Angeles–based screenwriter and blogger whose pop culture observations and multimedia creations have been cited in *Entertainment Weekly, US Magazine, The New York Times, Details, Spin, USA Today, The Washington Post*, and the *Houston Chronicle*, among other media outlets. In 2004, Ben co-founded the Web site TVgasm.com, which *Entertainment Weekly* labeled as one of the top twenty-five entertainment Web sites on the Internet. In 2007, he left the site after selling it to Bunim/Murray Productions. He also served as a writer's assistant on the Fox sitcom *Andy Richter Controls the Universe* and worked on various television productions such as *Late Night with Conan O'Brien, Strangers with Candy*, and the *WWE*. He currently authors the site bsideblog.com.

Wendy Merrill, author of *Falling into Manholes: The Memoir of a Bad/Good Girl*, is described by Anne Lamott as "a wonderful new voice—smart, funny and wildly real." Wendy runs WAM Marketing Group, a unique marketing communications company based in Sausalito, California, where she currently lives aboveground and beyond her means.

Helaine Olen is the coauthor of *Office Mate: The Employee Handbook for Finding—and Managing—Romance on the Job*. Her articles have been published in the *Los Angeles Times, The Washington Post*, Salon.com, AlterNet.org, and Condé Nast's

Cookie and the late *Portfolio*, among other places. She's also contributed to the anthologies *Modern Love* and *The Maternal Is Political*. She lives with her family in New York's Hudson Valley.

Neal Pollack is the author of the best-selling parenting memoir *Alternadad* as well as several works of satirical fiction, including the cult classic *The Neal Pollack Anthology of American Literature*. A contributor to many publications and Web sites, including *The New York Times, Vanity Fair, GQ, Men's Journal, Men's Health*, Slate.com, Salon.com, Nerve.com, and Parents. com, Pollack lives in Los Angeles with his family. Harper Perennial will publish his next book, *Stretch*, in the Summer 2010.

Richard Rushfield has written on subjects ranging from teenage witches to politics for publications including *The New York Times, Variety,* Slate.com, *VLife, Details, Los Angeles, Los Angeles Times Magazine, BlackBook, CMJ,* and *Elle Décor*. From 2000 to 2002, he wrote a column on film for *Arena* magazine. Since 1996, Richard and Adam Leff have co-authored *Vanity Fair*'s recurring infotainment feature, "The Intelligence Report." His novel, *On Spec*, was published by St. Martin's Press in 2000. From 2005 to 2009, he gave service as entertainment editor of latimes.com and contributed numerous pieces to the paper. He is the author of *Don't Follow Me, I'm Lost: A Memoir of Hampshire College in the Twilight of the '80s* (Gotham Books, 2008), and is currently writing *The Complete History of American Idol* (Hyperion), forthcoming Winter 2011. Richard currently lives in Venice, California, with his wife, journalist Nicole LaPorte.

Rex Sorgatz is a writer, designer, entrepreneur, and media consultant based in New York. He is a contributing editor at *Wired* and his work appears in *New York* magazine and on NPR. His consulting agency, Kinda Sorta Media, works with a wide range of Internet and media companies. A former executive producer of msnbc.com, he blogs his Internet life in real time at Fimoculous.com. He is working on a novel called *Everyone Is Famous*.

Jerry Stahl is the author of the narcotic memoir classic *Permanent Midnight* and the novels *Pain Killers; I, Fatty* (film rights optioned by Johnny Depp); *Perv—a Love Story*; and *Plainclothes Naked*. He has written extensively for film and television, and his much-anthologized fiction and journalism have appeared in *Esquire, Details, Playboy, BlackBook, LA Weekly,* and *Tin House*. He lives in Los Angeles.

Neil Strauss is the author of six *New York Times* best-selling books, including *Emergency, The Game,* Mötley Crüe's *The Dirt,* and Jenna Jameson's *How to Make Love Like a Porn Star*.

Stacey Grenrock Woods has written for numerous magazines and was a correspondent on *The Daily Show with Jon Stewart* for several years. She currently writes a monthly column for *Esquire*. Her first book, a memoir titled *I, California,* was published by Scribner in 2007. She lives in Los Angeles.

Toby Young is a British journalist and the author of the international best seller *How to Lose Friends and Alienate People* (2001) and *The Sound of No Hands Clapping* (2006). Young moved to New York in 1995 to work for *Vanity Fair*, where he was a contributing editor from 1995 to 1998. He is an associate editor of *The Spectator* and a restaurant critic for *The Independent on Sunday*. He has performed in the West End in a stage adaptation of *How to Lose Friends & Alienate People* and, in 2005, co-wrote (with fellow *Spectator* journalist Lloyd Evans) a sex farce called *Who's the Daddy?* It was named Best New Comedy at the 2006 Theatregoers' Choice Awards. He has appeared on numerous reality shows, most recently, as a regular judge on *Top Chef*. He co-produced the film version of *How to Lose Friends & Alienate People*, which starred Kirsten Dunst and Simon Pegg, and most recently co-wrote and co-produced a dramadoc called *When Boris Met Dave*. He lives in West London with his wife and four children.

ACKNOWLEDGMENTS

This book would be just one essay if I hadn't had eighteen fantastic contributors who brought more wit, originality, and intelligence to this rarely defended form of entertainment than I'd ever anticipated people could. So thank you James, Stacey, Mel, Neal, Jancee, Toby, Richard, Jerry, Amelie, Ben, Austin, John, Helaine, Will, Wendy, Mark, Rex, and Neil for transforming an idea into a book I love.

I'm also grateful to Carrie Kania and Cal Morgan for overseeing the project and Pilar Queen for making the deal. And thank you Bunim/Murray, Magical Elves, Endemol, Fremantle, Mike Fleiss, Adam DiVello, Dr. Drew Pinsky, and the many other producers who give we reality television fans—the mighty, the proud—so much to write about, obsess over, hate, and love.